GREAT WORKS

50 PAINTINGS EXPLORED

TOM LUBBOCK

GREAT WORKS

50 PAINTINGS EXPLORED

F

FRANCES LINCOLN LIMITED
PUBLISHERS

Frances Lincoln Limited
4 Torriano Mews
Torriano Avenue
London NW5 2RZ
www.franceslincoln.com

A catalogue record for this book is available from the British Library.

978-0-7112-3283-9

Printed and bound in China.

1 2 3 4 5 6 7 8 9

CONTENTS

INTRODUCTION

By Laura Cumming

Some critics on the *Independent* newspaper were once asked to write about their perfect pastime for an illustrated series – paragliding, classical ballet, perhaps fishing for marlin off Bermuda. Tom Lubbock's choice was to Sit Quietly By Himself in a Room. Needless to say, the paper did not like this suggestion of a pastime that cost nothing, yielded no advertising and couldn't be accompanied by spectacular photographs. His idea was binned, to Tom's gleeful amusement.

But what his readers lost was an essay on thinking, and thinking really was Tom's passion as well as his gift. Almost anything could be made interesting once it had passed through his mind, and what could not was material for humour. Ideas developed in his writing, as they did in his conversation, with exacting clarity and a stupendous range of registers: mirthful, argumentative, celebratory, probing, contemplative, comic. The mind represented all the freedom in the world to Tom; it was bigger than any room.

And what he thought about most in the last two decades of his professional life was art. By the time of his death, just days after his fifty-third birthday in 2011, Tom Lubbock was widely considered the most original art writer in Britain; quite possibly the most industrious too. You could read him not once but three times a week in the *Independent*, where his Details competition had a strong following (including several famous artists) for its pithy critiques of famous art, and his Monday reviews were eagerly awaited by the hordes of readers who admired and learned from his fearlessly honest examinations of art, both old and contemporary. As a critic he had perfect judgement, which time will surely prove, but more than that his approach was unique. He saw art as an experience both *in* and *of* life; for him the two were not separate; each could illuminate and enrich the other. Holbein and the Airfix kits of childhood, Rothko and the anthems of Mariah Carey, conceptual art and the uses of the electric toaster: every review was a heady adventure.

But it was the Great Works series, which began in 2005 and continued virtually up to his death, that offered Tom the maximum freedom. These short essays were not time-tied or pegged to a show. He could choose to bring to life paintings that had lain dormant for years – look at the startling baby on the

cover of this book, taken from a picture by Philipp Otto Runge, which inspired a wonderful essay on self-contained details, and the sudden arrival of self-contained babies – and he could choose to concentrate on the great art that is often ignored. Instead of Giotto's full-colour frescoes in the Arena Chapel, for example, Tom explores the black-and-white Noh play of the *Vices*; instead of *The Raft of the Medusa*, he takes one of Géricault's preparatory studies as the starting point for an argument about sex in painting that builds to the persuasive assertion that *Study of Truncated Limbs* may show a heap of human remains but is quite possibly the one true depiction of post-coital sensuousness in art.

The first excitement on leafing through the paper to Tom's Great Works – so aptly named, as people said – was discovering where he would start (and how he would get to the Work). The light hidden inside the glass of milk in Hitchcock's *Suspicion* is a revelation in itself, but Tom uses it to analyse the sacramental glow of a Zurbarán. The ideas of the French mystic Simone Weil help him to clinch the mysterious atmosphere of Edward Hopper's *Early Sunday Morning*. How would he negotiate between James Joyce's *Ulysses* and Ingres's *Madame Moitessier*, or even more hazardously from Venn diagrams to a portrait by Rembrandt? The reader's curiosity was piqued by these wild analogies; and then it was abundantly rewarded.

In Great Works, Tom wrote about the relationship between painting and theatre, between words and pictures, between illusions and cinematic effects. He considered aspects of art that are commonly overlooked: sight gags and slapstick, paintings and puppet shows, games of hide and seek, blips where the painting stops making sense. How the shape or scale of a picture orchestrates the drama, how a painting can ever convey – rather than just tidily describe – a mess.

The essays made one think about art in a whole new way. The picture was to be considered on – and as – its own evidence, first and last. Tom did not examine paintings, as others do, through the prism of theory, scholarship, art or social history, though he was erudite in all. Tellingly, his artists' biographies always appear as self-contained footnotes. A model of what was interesting, and not rote – 'Painting was perhaps not Vermeer's main job. He had a line as an inn-

keeper' – these sketches would make a brilliant anthology of brief lives.

Like John Berger, with whom he has been compared, Tom proposed new ways of seeing. Try the mirror trick in the essay on Daumier and you will learn something about optics, bodies and the disparities between two and three dimensions, not to mention the greatness of this French cartoonist and painter (tellingly, one of Tom's favourites). Take up crayon and scissors, or their modern equivalent in Photoshop, and follow his suggestion of moving or deleting the bird in Van Gogh's *Wheatfield with Lark*. Through this ruse – and of course Tom's observations – you will appreciate the painting far more.

'The lighting tells the time.' 'The scene says "etc".' 'Art invents the world from scratch.' Tom's writing is addictively clear and epigrammatic; he liked to hunt down the *mot juste*, to turn an argument on the proverbial sixpence. He probably brought more people to art than many a scholar simply by being intellectually lucid and funny. Above all, he wrote about these great works, and this remains unique, as if they were autonomous beings in themselves.

What can a painting believe? he would ask. What sort of jokes can it tell? What kind of language does it speak? In the essay on Gwen John, he even imagines what it is like to be inside a painting, immobilised and flattened and unable to stand free. It is a profound vision of the inner life of art, and of this artist's paintings.

Tom was a stickler for truth, a mocker of cant; he was also leery of the unfocused emotional response. But reading these essays, with their formidable knowledge of art, poetry, music, philosophy and film, one feels that some of his own traits are reflected in the chosen works – inventiveness, wit, acute and fearless intelligence. In the marvellous essay on Proust and Vermeer's *View of Delft*, written when he was about to undergo emergency brain surgery for the brain tumour that would kill him, he imagines losing consciousness even while contemplating the difference between painting and fiction. It is classic Tom: proposition, revelation, prose into poetry. What he prized in art – mental freedom, as he wrote – is exactly what he shows here, and what he will continue to inspire in his readers.

GREAT WORKS

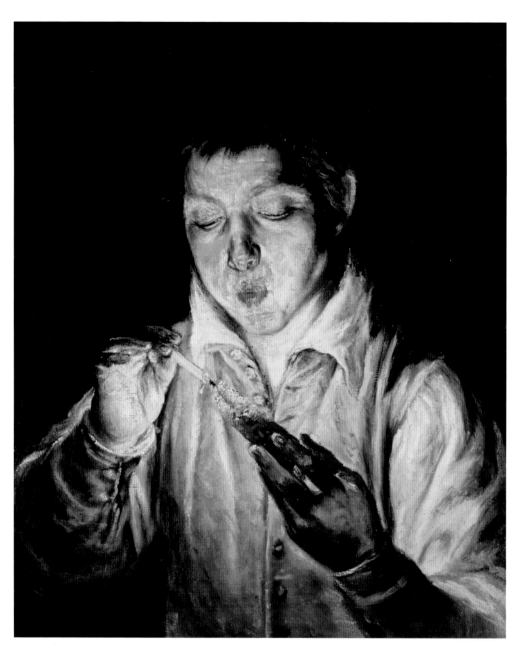

Boy Lighting a Candle 1570–75
Oil on canvas, 60.5 x 50.5 cm
Museo di Capodimonte, Naples

EL GRECO

Imagine three short films.

Imagine a film of a kitchen sink. The cold tap is running, releasing a continuous flow of water into the sink. But when you first look at the image everything seems still. It's a calm and gleaming scene of metal and ceramic. It's only after a while that you notice the flow of water, and realise why you hadn't noticed it before. The tap is on, but only just. It emits a thin, clear, perfectly steady vertical spine of water, a liquid column that flows into the sink without any spitting or foaming or wobble or pulse, without the least variation in its appearance. You're looking at something in movement, whose movement is invisible.

Imagine a film of a man in mid-air, falling. He's plunging through space, with a cliff face behind him, and as he falls, the camera stays close with him, following him down, and the cliff keeps rushing upwards – and it seems that soon he must make impact with whatever it is, ground or water, that lies at the foot of the cliff. But no, he goes on falling, for an impossible duration, and you eventually realise, because you start to notice repetitions, that somewhere in the film there must be a seamless join. The man's descent is held in a perpetual loop, and he will never land. But hold onto the point before you realised this. You're in the middle of a process that has a limited span, and won't take long, but you can't tell how far through you are. The imminent climax is continually deferred. Any moment now . . . but when?

Imagine a film of a man on a bicycle. It's a stationary exercise bicycle, and he's pedalling away for all he's worth. It is night, or anyway a place of total darkness, and all that illuminates this cyclist is a small spotlight aimed at his body. He goes on pedalling hard, and you begin to wonder what he's really doing, or what the point is of this strenuous nocturnal scene, until you perceive that from time to time there's some slight fluctuation in the strength of the lighting; and then you notice that there's a cable running from the light to the bicycle, and it's attached to a dynamo on the bicycle, and that the man is pedalling in order to make the light shine. His visibility, in other words, is dependent on his activity.

Now imagine these three short films turned into three still images. Each one would be curious. With movement that doesn't show, there'd be no difference between a film and a still. With an imminent, suspended climax, you wouldn't need any looping trickery, the still image by itself would put things on hold, and maintain an endless 'any moment now'. With the lighting-generator, the subject's visibility wouldn't be – what it normally is in pictures – an assumption. It would be a contingency. You'd have a scene that implied a change of scene, where the light was out and everything was lost.

And now imagine these three effects in a single picture. Or rather, here it is.

El Greco's *Boy Lighting a Candle* shows a boy blowing on an ember. It's an action that, while it lasts, can be perfectly steady and show no change. The passage of the air is invisible. The pursed lips, the glow of the ember, the hold of the hands: all these things can stay as they are for a while. It is movement without any movement to be seen, while it lasts. Of course this process can't continue for ever. His lungs will soon run out of air. Who knows how much puff is left? We can't tell, but it can't last. And when the boy's breath fails, the ember will fade too, and the whole scene, lit entirely from this light source, will revert to darkness – unless he can get the candle to catch and hold on to that light in time.

It is one of the great pictorial subjects. With its play between stillness and timing and visibility, between breath and light, it's rich in allegorical possibilities, in thoughts of life and death. At the same time it's based on a simple, natural physical event – the beautiful two-way relationship between a face and an ember. The face blows air upon the ember, causing the ember to shine back upon the face. The boy puffs himself into light. While he breathes, he is there before us.

It's painted in the most realistic style El Greco ever used, and it looks like everyday life. It was inspired by classical example. Almost no paintings survive from ancient Greece, but many are described by the Roman author, Pliny the Elder, in his encyclopaedic work *Natural History*. Post-Renaissance artists often tried to recreate them. El Greco painted several versions and variants of this subject. So did other artists, after him, in the following century.

It's not clear, though, whether any of them realised the original idea in full. Because what Pliny describes is not just a picture, it's an installation. He talks about the artist 'Antiphilus, who is praised for his *Boy Blowing a Fire*, and for the apartment, beautiful in itself, lit by the reflection from the fire and the light thrown on the boy's face . . .'

This seems to mean that the original picture was shown in a specially designed room, where it was lit only by the fire in the grate. That would really up the effect, in terms of animation and viewer-involvement. The fire's flickering glow would give an appearance of slight but real movement to the still image. It would make it look like an act of blowing was really being indefinitely sustained. It might even make you feel (as you looked at the picture, not the fire) that it was the image itself that lit the room – which would in turn put the illumination of the room you stood in under threat of imminent blackout.

Domenikos Theotocopoulos (1541–1614) was born in Crete, where he trained as an icon painter in the Byzantine tradition. He moved to Italy, and assimilated the Renaissance accomplishments of Venice and Rome. He ended up in Spain, where he acquired his lasting nickname, The Greek, and turned into one of the strangest painters in the Western tradition. His subjects are mostly religious. His effects are visionary, to put it mildly – images that explode before your eyes in livid lightning flashes and metallic colours, that stretch and shrink as in a fairground mirror, that switch angles, swerve, shoot off, fragment, utterly disintegrate and dissolve, and suddenly become very clear. The only other top artist called El is the twentieth-century Russian Constructivist, El Lissitzky.

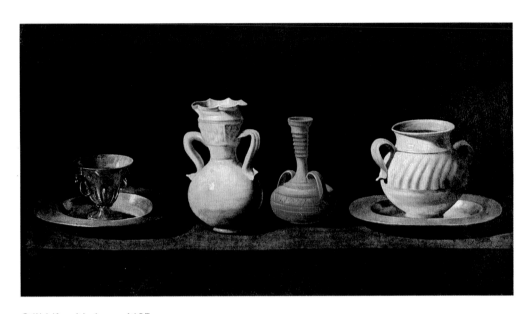

Still Life with Jars c.1635
Oil on canvas, 46 x 84 cm
Prado, Madrid

FRANCISCO DE ZURBARÁN

Alfred Hitchcock was proud of his tricks. There's a good one in *Suspicion*, his 1941 film about a man who may well be trying to murder his wife. When, 30 years later, Hitchcock did a series of interviews with the French director, François Truffaut, he wanted to be sure the trick hadn't been missed.

> *AH*: By the way, did you like the scene with the glass of milk?
> *FT*: When Cary Grant takes it upstairs? Yes, it was very good.
> *AH*: I put a light in the milk.
> *FT*: You mean a spotlight on it?
> *AH*: No, I put a light right inside the glass because I wanted it to be luminous. Cary Grant's walking upstairs and everyone's attention had to be focused on that glass.

Because, of course, the milk in the glass may be spiked. And you can see why a spotlight wouldn't do. The glass is on the move, carried upstairs on a tray. It might be hard to track it steadily. More than that, it would be hard for a spot to pick out the glass alone, without shedding light and casting shadow, and making it clear that lighting was being used deliberately to direct our attention.

The emphasis needed to be subliminal. We mustn't feel too nudged. *Suspicion* is all about not being sure. We should feel it's the inherent suspiciousness of this glass of milk, the possibility that it's doped, that makes it so interesting to us. And if the glass's luminosity is itself a little weird, a little mysterious, that only strengthens the effect.

Long afterwards, when it had done its work, Hitchcock was happy to make all clear. And when you know, what strikes you is the outrageous artifice of this solution, its head-on defiance of naturalism. Make something conspicuous? Put a light bulb in it!

Things that count as special effects in cinema are normal business in paintings. If a painting wants to give particular emphasis to something, no problem, it has numerous means at its disposal. It can do what it likes with lighting and luminosity. It doesn't have to come up with brilliant solutions because, unlike the photographic arts, it doesn't have to deal with the resistance

of the real world. Painting remakes its world from scratch. All the same, some painting puts a premium on having an appearance of high realism. In which case, its tricks may need to get a bit clever.

Francisco de Zurbarán painted less than a handful of still lives. Their subjects are simple and few, pieces of fruit, baskets, vessels, plates, a flower. Their scenarios are simple too, a narrow shelf with objects laid along it, lit by a shaft of strong light coming almost directly from the left. This *Still Life with Jars* is one of them. It has no organic matter, only man-made objects. The treatment is highly realistic. The painting does all it can to make us believe in these things, in their shaded rounded volumes, their hard gleaming surfaces. It makes them tangibly solid. It makes them *audibly* solid. It makes you imagine the sound they'd make, when the clay pot is put down on the shelf, when the brass cup is set in the thin silver platter. It's a level of realism you might well call magical.

But these objects are magical in another way. They have a heightened presence, which realism alone doesn't account for, which realism actually makes mysterious. Somehow these ordinary material things feel mystical, numinous, holy. The jars are utterly real *and* utterly supernatural. That's the power of the image, this ambiguous balance. It's also a puzzle. How does Zurbarán get the visionary effect with such plain, nothing-up-his-sleeve, all-above-board ingredients? There has to be a trick.

There is. It's partly in the layout and partly in the lighting. The vessels appear before us in a solemn procession across the picture-stage. But they're not paraded overtly, like soldiers. They're not set on a single line; some are nearer than others. They're not evenly spaced either. But the picture adjusts the differing shapes, heights, widths, brightness, colours of the four vessels – and two plates – into a visual equilibrium. Result: there is no protagonist among them. Each is very different. All have equal weight. The row looks casual, but holds a perfect, subliminal order.

That seems a respectable artistic effect. When it comes to the lighting, the tricks get trickier. The depicted facts say one thing, that these objects are illuminated, lit by a light source from the left. The impression they give is

something else: not illuminated, but luminous. Like the glass of dodgy milk in *Suspicion*, they glow. What's going on?

Look at the strength and at the direction of the falling light. There are discrepancies both ways. Clearly the light hits the vessels very strongly – but then doesn't hit the surface of the shelf nearly so strongly. Strangely, the level of illumination has dimmed by several degrees between pots and shelf-top. The vessels stand out from their setting, a row of lights in the darkness.

And then, observe the shadows they cast. They do cast shadows, which correspond to the direction of the light. They cast them on the surface of the shelf. But *they don't cast them on the other vessels*. No vessel interrupts the lighting of its neighbour. It's as if, although lined-up and side-lit, each vessel had a special light source all of its own.

Of course it can be hard to say precisely where the shadows ought to fall. But surely the far right vessel should cast one on its plate – and doesn't, causing the plate to glow unnaturally. And certainly the tall white vase, left centre, should block the light from the red, high-necked vase beside it, and doesn't. Its shadow falls round the red vase's base, but the red vase itself stays inexplicably, miraculously illuminated. These are tricks Hitchcock might have been proud of, even though the name of the picture now is *Sanctification*.

Francisco de Zurbarán (1598–1664) painted the light of God. The Spanish artist worked mainly for churches and monasteries, doing images of saints and martyrs, visions and crucifixions. Inspired, like so many of his contemporaries, by the high-contrast lighting of Caravaggio, he devised a series of stunning dramas out of visibility. A typical image: a standing figure, often in monastic robes, stands against a dark background, in a narrow sentry box frame – caught in this frame and caught in a shaft of light, held visible to the Christian viewer and to the eye of God, bearing witness. Still life elements are sometimes emphasised too, a book, a loaf, a basket. Just occasionally they have a picture to themselves, where they're imbued with a sacramental feeling. Everything feels seen.

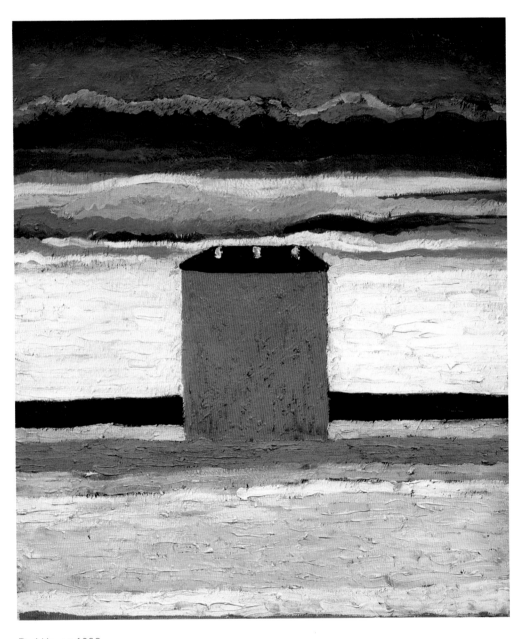

Red House 1932
Oil on canvas, 65 x 55 cm
State Russian Museum, St Petersburg

KAZIMIR MALEVICH

Faces: we can find them anywhere. We're deeply inclined to facial recognition, to perceiving faces in things and putting faces on things. The world for us is full of eyes, noses and mouths, imagined or appended, from the man in the moon to the snarling snout of a fighter plane.

But facial experience isn't only a matter of facial features. We give faces to things that have no physiognomy. They simply have a front, a face they can present. Coins have faces, clocks have faces, buildings have façades. That is, they hold the possibility of a face-to-face relationship. You can divide the world up like this. Some things have an established front, a face that can face us; some things don't.

Pictures themselves have faces. You can look at a building from the front and from the side, but when you're viewing a picture you only look at it front on. A conservator may be interested in the all-round physical condition of a painting. From a viewer it demands face-to-face attention.

But pictures also depict things that have faces: not just human faces, but any of those other things that have fronts, that can face us. And sometimes these things will be depicted so that their faces are turned directly towards the viewer. So a picture can involve us in a twofold facial relationship. Always, it asks us to look at it face on. Sometimes, as well, it shows us something face on.

Kazimir Malevich's *Red House* is a simple picture. Don't call it deceptively simple: if any picture is simple, this one is. It shows a red house with a black roof, a house that might well have been painted by a child, standing in a landscape of horizontal stripes.

Admittedly, when you try to describe the scene in more detail, uncertainties arise. As with a child's picture, you find yourself asking: what's that meant to be? The clues are minimal, and you can't be sure. Take the stripy background. Is it a receding view of the world, or the world shown in cross-section?

Look at the coloured stripes in the lower part of the picture, from the strong black stripe downwards. You could see them as strips of land, of varying width, coming towards you from a horizon. Or you could see them as geological layers of soil, going downwards through the earth.

Likewise, in the upper part, the fluctuating stripes of blue/white can be seen as ascending layers of cloudy sky – with the wide central white band behind the house as maybe 'empty' air between ground and sky. (In a kid's picture, the sky is often just a layer across the top of the image.) But equally, or more plausibly, you could see these blue and white stripes as a tipped-up view of the sea, breaking waves, stretching away into the distance beyond the house. The wide white band now becomes the beach.

Actually, these background uncertainties are not very important. *Red House* is a picture that knows one big thing: its power is in the red house itself. It's in the way that this red house is so strongly present, the way that – though it has no features – it insistently stands and faces us.

The house is almost just a flat red shape. Not quite. It has its landscape setting, and the reason is so that we don't see it as *just* a shape, we see it as a house occupying some kind of space, a house that might therefore be turned some other way, seen from some other angle, but is in fact turned directly to face us. However you read the background, this house stands with its façade facing front.

At the same time, of course, it is a shape. The front-on façade of the house becomes a plain red rectangle, lying flat on the surface of the painting. Forget about the house now. As you stand facing the canvas, this flat, red oblong faces you. It is simply the focus for your face-to-face with the picture itself, an oblong within its oblong.

Malevich makes that relationship tight. The proportions of the red oblong are the same as the proportions of the canvas. The oblong is an internal miniature of the whole picture. It is also centred in it. At the left, the right and the bottom, the margins between the oblong and the edges of the picture are of equal width. The red oblong is snugly lodged within the picture's frame. Its position is made firm.

This width is not repeated in the top margin. It can't be, if the internal oblong and the whole picture are to keep the same proportions. A perfect, all-the-way-round centring is only possible with a square within a square.

And squares here would be a bad idea. *Red House* needs to be an oblong – specifically an upright, upstanding oblong. The house and the picture don't just offer a direct face-off with the viewer, they also imitate the viewer's standing posture. They stand up before you, stand and face you, as you stand and face them.

Pure confrontation: that's the simple impact of *Red House*. It has no face, but it faces us hard. OK, maybe there's a hint of physiognomy, in the black roof that's rather like a piece of hair. Maybe the way the house sits on the ground has a suggestion of head and shoulders. Maybe the three white dots/windows are a little eye-like. But still, an image that has no gaze at all can do the traditional trick, and seem to follow you round the room.

Kazimir Malevich (1878–1935) made the great reduction. In 1914 he painted the Suprematist *Black Square*, a painting that was just a plain black square with a white margin. A series of pure geometrical abstractions followed, battlefields of multi-coloured shapes. The revolution in Russian art coincided with the political revolution, and for a while worked in tandem. Then state policy demanded more accessible art, and the experimenters stalled. Malevich's later years switch between academic realism and half-abstract figures or landscapes. But all through, the paintings face us: the blank masks, the straight portraits, the houses, even the pure squares. 'Any painting surface is more alive than any face,' Malevich said. 'The *Square* is a living royal infant.'

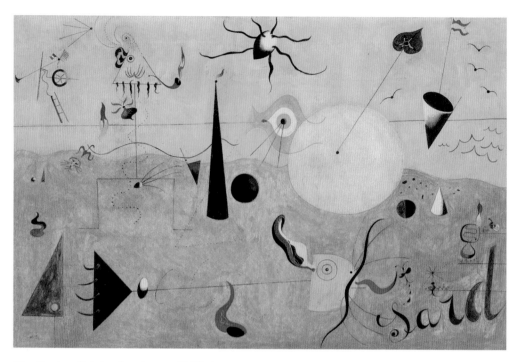

The Hunter, Catalan Landscape 1923–4
Oil on canvas, 64.8 x 100.3 cm
Museum of Modern Art, New York

JOAN MIRÓ

Take the stick figure, the pin man, in its purest form. You have five single lines, straight or bent, that stand for arms, legs, torso – plus an enlarged dot for the head. It's a strictly limited image of the human form. Some things it can tell you, and some things it can't. It carries basic anatomical information about our species, the upright biped. It can indicate something of a body's position and activity. What this simple figure won't reveal is anything about a body's shape, or sex, or colour, or hair, or whether it's clothed or naked. Such matters are outside the stick figure's repertoire.

The pure stick figure is quite a specialised and sophisticated form of notation, used in signs and diagrams. So far as child development goes, it's by no means primitive. Kids usually start drawing the human figure as a cephalopod, a kind of tadpole. There's an outlined blob, a rough round, with two single lines coming down from it. The blob represents the head, the two lines are legs. There are no arms. As for the torso, when asked to show where the tummy is, some children locate it within the head-blob, others just under the blob between the leg-lines.

These early child drawings already use two types of line: outline, marking the edge of a shape, and stick-lines, standing for something long. Developed realistic drawing uses outline, of course, and many other types of line – lines that mean creases, ridges, surface markings, shading etc. It uses hair-lines too, single lines that depict things that are very thin, such as hairs, twigs, wires, strings, insect legs. But stick-lines proper, single lines that stand for relatively thick items, like a limb or a torso, aren't permitted in realistic drawings. Such items should be depicted with outlines. If you start introducing stick figures into realistic drawing, the effect will be weird.

Sometimes it is done, deliberately. For instance, in *Struwwelpeter*, the book of hair-raising cautionary rhymes created by Heinrich Hoffmann in the middle of the nineteenth century, you find the tale of 'Augustus, who would not eat his soup.' 'Augustus was a chubby lad, fat rosy cheeks Augustus had . . .' the rhyme begins. But then he becomes picky. He refuses to take his daily bowl of

soup. He declines rapidly. By day four of his food-strike he is totally skeletal, or indeed something worse.

The illustration shows Augustus still in his Victorian little boy's frock, but his formerly bouncing body is not just very thin. He has become a stick figure. Since *Struwwelpeter*'s illustrations are fairly realistic, it's a disturbing device. Within the style, these lines can only be hair-lines, meaning Augustus has now become unbelievably thin, as thin as a spider's leg. But it could be that, in response to his extreme emaciation, the image has just jumped style, into a form of drawing that carries no shape information at all. Augustus is *beyond thin*, not really a body at all, just lines in the air. It's actually a relief when on day four he's safely in his grave.

In modern art, this practice can go wilder. In Joan Miró's *The Hunter, Catalan Landscape* you find it happening everywhere. True, there are some orientation points in this weightless, linear scene. It has a landscape structure: a stretch of pinkish foreground, with beyond it a yellow sea coming to a horizon, and above that sky, also yellow. On the left stands the hunter with a black conical gun beside him. At the front there's a whiskered creature, which can be seen as a sardine or a rabbit. There are outbreaks of waves and seagulls on the right. But identification soon gets hard. The round blob with the eye and the clock-hand – what's that?

The image takes legibility to the limit. It is a fantastic mix-up, a miscellany of almost every possible way a line can be used. You find line-types from realistic drawing, child drawing, cartoons, diagrams and geometry. There are lines that mean rays of light and trajectory paths and radiations. There are full lines and dotted lines. It's not quite a complete anthology of line. For example, I can't find any shudder lines (as from a cartoon fight) or heat or odour lines (as from a cartoon pie or smelly sock). But there are a couple of turds on the ground with flame-like emanations, representing their smell – and these smell shapes echo the rabbit's red tongue and various other things. In fact, there are lots of visual puns to be spotted.

It's an anarchic, pluralistic, playful scene. Its miscegenation is exuberant.

Individual entities are built from a multitude of mutually exclusive styles. The hunter himself is mainly a stick figure, but he has a triangle head, with black tufts of beard hanging from its bottom line as if from a washing line, and a quite realistic burning pipe, and a little flaming grenade of a heart, floating in the air where his non-existent breast should be. The wavy stick-line that means his arms is easily confused with the outlines that mean land-edge and sea-horizon. The scale of things is all over the place. The black round ball is probably his gun's bullet.

But if the play was only about what-means-what, it wouldn't be so piquant. As in 'Augustus', there's also a play of sensation. Miró wrote of making 'a line or a point, just by itself, into something you can feel'. Here outlines and hair-lines and stick-lines get muddled up and lose their identities. The feeling of the world becomes unstable. Bodies shift, disintegrate, go solid and threadbare and totally unsubstantial. It's a picture you can sense between your fingers, and you get an uncomfortable metamorphosis of balloon-skins, cheese-wires, bristles, blades and thin air. Miró-world may be a light, jolly, playful place, but – like *Struwwelpeter* – it has a cruel turn.

Joan Miró (1893–1983) was a maker of worlds. The Catalan painter became a modern art version of the old visionary Hieronymus Bosch. He took a hint from the play of styles in Picasso's Cubism, and let it breed. The Miró cosmos is a half-fun, half-loony phantasmagoria, a swarming suspension of insects, sperms, eyes, blobs, paper decorations, dots, body parts, whiskers, amoebae, turds, letters, stars. There's a sophisticated surreal pursuit of weirdness and craziness – and at the same time, a farm boy's sense of the ungraspable multiplicity and interaction of the natural world. In the 1920s, his creativity moves at an incredible pace. From 1940, the trademark style is set, and endlessly, pointlessly repeated for decades.

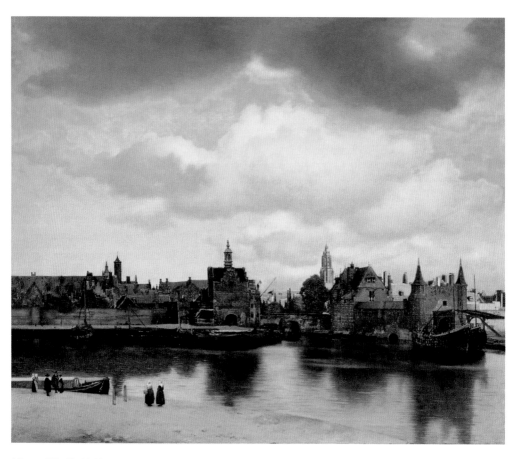

View of Delft 1660
Oil on canvas, 98 x 117.5 cm
Mauritshuis, The Hague

JOHANNES VERMEER

There are works where a single detail steals the show. Leonardo's *Mona Lisa* is famous for that smile. Michelangelo's *Creation of Adam* is famous for those hands. And Vermeer's *View of Delft* – well, not quite so famous. But amongst readers of Proust, at least, the painting can't be recalled without a mention of one particular bit.

It's a picture you mightn't expect to break down into bits. It seems so seamlessly photographic. But on a nearer look, Vermeer's paint surface separates out into a pattern of light-readings, into dots and dabs and patches of colour. It's one of those.

In volume five of *À La Recherche du temps perdu*, the novelist Bergotte dies. He dies in a gallery, at an exhibition of Dutch paintings, in front of the *View of Delft*. He fixes his last living look on that picture, homing in on a detail of it, which had been pointed out by a critic in a newspaper:

> At last he came to the Vermeer, which he remembered as more striking, more different from anything else he knew, but in which, thanks to the critic's article, he noticed for the first time some small figures in blue, that the sand was pink, and, finally, the precious substance of the tiny patch of yellow wall. His dizziness increased; he fixed his gaze, like a child upon a yellow butterfly that it wants to catch, on the precious little patch of wall. 'That's how I ought to have written,' he said. 'My last books are too dry, I ought to have gone over them with a few layers of colour, made my language precious in itself, like this little patch of yellow wall . . .'
> He repeated to himself: 'Little patch of yellow wall, with a sloping roof, little patch of yellow wall.'

Petit pan de mur jaune . . . Which patch is it, though?

The point is disputed. There are several possibilities in the cluster of buildings at the right end of the far shore. The most obvious is the glimpse of yellow roof (not wall) to the left of the turreted building. The next is the strip of bright wall (not especially yellow) to the right of the turreted building. When

he wrote, Proust was probably working from memory – or a black and white reproduction.

But assume the oblong of roof. There's a question you can ask about any famous detail. Does it work by itself, or does it only work in the context of the whole picture? If you extracted the detail, would it be a strong picture in its own right, or would it be hard to see what the fuss was about?

The passage suggests that the little patch all by itself, the sheer precious substance of its painting, so dense and luminous, is what transfixes Bergotte. But the picture suggests otherwise. It's only within the whole view that this patch – suddenly brighter and purer than you'd expect, and with its yellow animated by the adjacent reds and blues (Vermeer was always a great one for the primaries) – blazes out. It's not a self-sufficient and extractable gem. It's an integrated effect, a climactic note.

In other words, Bergotte dies under an illusion. His illusion is normal enough. With any climactic note, we tend to feel it can be isolated and extracted – that its power and preciousness lie somehow within itself, rather than depending on what it's a climax to.

But this is why it's such a good image of the man's fading consciousness and will to live. Bergotte wants to see this detail as a separately precious thing, something he can isolate and grasp in his hand. Yet he can't – any more than he can hold onto this last precious moment of his life.

Johannes Vermeer (1632–75) remains a famous mystery. The 'Sphinx of Delft' was rediscovered in the middle of the nineteenth century. In the twentieth century his work became the epitome of artistic perfection. Its watchwords are stillness, silence, containment, privacy, meditation, illumination. Painting was perhaps not Vermeer's main job. He had a line as an innkeeper and art-dealer. About thirty-five pictures survive, mainly interiors, occupied only by youngish people, mainly young women. They sit or stand in white rooms, absorbed, bathed in a holy light. There is no certain self-portrait. In his painting of an artist at work, the painter has his back firmly turned.

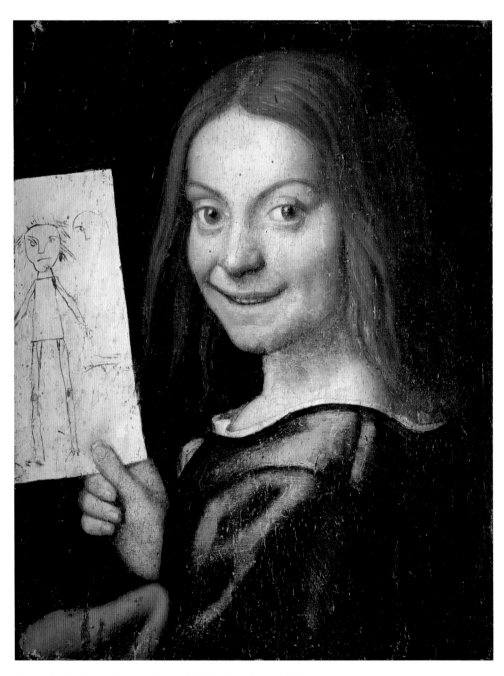

Portrait of a Young Boy holding a Child's Drawing c.1515
Oil on panel, 37 x 29 cm
Museo di Castelvecchio, Verona

GIOVANNI FRANCESCO CAROTO

When Picasso went to a show of children's art, he remarked: 'When I was their age I could draw like Raphael; but it took me a lifetime to learn to draw like them.' He wasn't alone in this ambition. Primitivism was a big thing in modern art; along with tribesmen and the insane, good European children were a model of the primitive. Many twentieth-century artists tried to draw like kids: Kandinsky, Klee, Miró, Dubuffet . . .

They didn't always succeed. Partly they didn't want to. Child art was an inspiration, not a template. Most of these artists used it as a resource, combined its naiveties with more sophisticated procedures. But partly, as Picasso pointed out, to really draw like children is very difficult.

Child art has several distinctive aspects. Some can be picked up easily. There is the 'conceptual' anatomy, the figure made of definitive bits – head, hairs, body, arms, hands, fingers, each a separate blob or stick. There is the 'map-like' view of the world, same-scale figures laid out all over the page, or the 'section' view, with a ground-strip at the bottom of the page and a blue sky-strip at the top. There are the fixed angles: trains and horses shown from the side, faces and houses from the front.

But the most telltale characteristic, and by far the hardest to imitate, is simply the quality of a child's drawn line. It's wrong to think of it as wildness. That wouldn't be so tricky. You can lose control and fling your flailing arm at a page at any age.

Child art is not pure wildness. Children are trying to get something right. They want to but they can't. Their drawing desires are ahead of their bodily knacks. And this gap between want and can't – this failure – is the secret of children's drawing. It's where its charm lies. The tension between want and can't is what gives children's lines their electricity. This failure is what taught adults find so hard to imitate.

Once you've been taught – and the teaching involves much more than mere art teaching, it involves all the physical training you get in childhood, designed to turn you into an operating and coordinated person – your body will never let you down in quite the same way. This know-how is in your muscles. Even

useless adult drawers can't draw like children. Give them a drawing task and their age will show. Their bodies can't fail like that now.

To recapture that state hasn't got much to do with innocence or spontaneity. So put aside Primitivism. But any artist might be curious – and basically they have two options. They can try to unlearn what their body has learnt through its upbringing and training. Or they can fake it, using their most perfected skills to copy literally from the real thing.

Around the time when Raphael was at the height of his powers, a minor Veronese painter made his great one-off. Giovanni Francesco Caroto painted the *Portrait of a Young Boy holding a Child's Drawing*. The boy's eager, slightly toothsome smile gives this picture a place in the history of portraiture. But the page he holds upstages it. It's the first depiction of child art in a European painting.

Whoever the boy is, this stick man is presumably meant to be his own work, proudly presented. But study the sheet more closely. Lower right, notice the profile eye, drawn with an expert hand. We can imagine the boy hanging around the studio, picking up bits of paper used by the artist or his pupils for sketches, adding his own.

But what of the stick man itself? It's an attempt by an experienced artist to imitate a child's handiwork. It's uneven. The scratchy, wobbly lines are persuasive. Some of the formations look too complex – see its right eye, constructed from curved eyebrow and eyelid. Indeed the incomplete head in the corner suggests a grown-up approach. Children of this age push ahead, don't have a second try.

And of course, this drawing is not a drawing. It's a painting of a drawing, made in the infinitely correctible medium of oil paint. Caroto has closely observed how children draw. He probably hasn't tried to unteach his own hand. He has faked it. And in his careful copying he has preserved for us evidence that while art styles change, children 500 years ago failed as they do today.

Giovanni Francesco Caroto (1480–1555) was a Veronese artist. Vasari has him down as a pupil of Liberale da Verona, himself a follower of Mantegna. After a stay in Milan, Caroto began looking to Leonardo, Raphael and Giulio Romano. His portrait faces are odd, slightly off. In the context of his other work, this painting, of uncertain date, is a *jeu d'esprit*. He did nothing else like it.

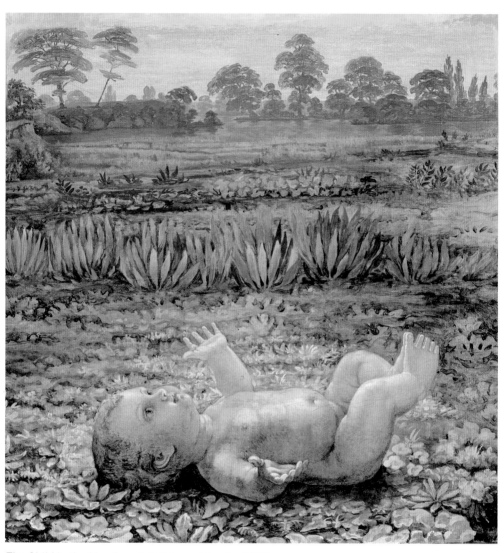

The Child in the Meadow, detail from *Morning* 1809
Oil on canvas, 152 x 113 cm
Kunsthalle, Hamburg

PHILIPP OTTO RUNGE

A work of art, or so they say, should be more than the sum of its parts. Maybe. But it is also the sum of its parts. And it is also its parts, one by one. When it comes to pictures, it may not be so obvious what the parts are. Unlike a text, a picture has no clear internal breaks. It doesn't divide up into words and sentences, lines and paragraphs. When you take a detail from a painting, its exact size and shape and edges are rather up to you. Still, pictures do often visibly come to pieces.

Just as literature has its famous quotations, painting has its famous details. Look at the postcard racks in any gallery shop, if you want to know what they are (an obvious example would be the almost-touching hands of God and Adam from Michelangelo's fresco).

Perhaps this approach seems wrong. We're taught than an artwork should be a unified and harmonious whole. It may feel frivolous or philistine to have an eye just for the good bits. But don't overlook the fact that many artists of the past weren't only trying to be harmonious etc. Just like writers, they were trying to be quotable too.

When you read traditional art criticism, you find the critics are always pointing out this or that detail as especially striking and worthy of admiration. Ever since the ancient Greek painter Timanthes, remembered for a single touch – how he portrayed the grief-stricken face of Agamemnon hidden behind a cloak – the history of art has often been a parade of telling details. And there are pictures where a detail doesn't merely catch the eye or steal the scene. It demands to be a picture all of its own.

The picture here is only a detail. It comes from Philipp Otto Runge's great project, *The Times of Day*. This was a painting sequence that consisted of four allegorical scenes – Morning, Day, Evening, Night – depicting a universal, elemental mythology. The images, tall as altar paintings, showed earth and sky, figures, flowers and stars in geometrical compositions. Their forms and colour schemes were carefully calculated. They were to be displayed in a purpose-built sanctuary, accompanied by music and poetry.

Ars longa, vita brevis. At his early death, aged thirty-three, Runge still hadn't

completed the first picture, *Morning*. He suggested that the unfinished canvas should be cut up into its more or less finished parts. Later on it was. One of these pieces shows a naked baby lying on the ground. It comes from the middle of the bottom of *Morning*. As a fragment it was given a new title of its own, *The Child in the Meadow*.

It works well as a self-sufficient image. Even though the separated parts of *Morning* have now been stuck back together again (with some gaps between them), Runge's deathbed solution makes visible sense. *Morning* as a whole was composed of isolated incidents. It could easily be cut up into pieces, without cutting anything important in half. What's more, this particular fragment, partly because it is a fragment, acquires a peculiar power.

The baby: it's not Jesus, not precisely. It looks like Jesus, of course, very like him, as he appears in many Nativity scenes, lying naked on the ground, with quite a bit of space around him. The echo is plain, and plainly intended. So is the difference. This is a divine baby, yes – but non-specifically divine. It's not the virgin-born Christ child of the Christians. It's a universal symbol of the miracle of birth. (And, unlike in many Nativities, Runge leaves the child's sex unclear.)

In other words, in the picture Runge has performed a kind of collage. *The Child in the Meadow*, this detail cut out from *Morning*, is itself like a detail cut out from a typical Nativity painting. It extracts the baby alone, removes it from its specifically Christian context and story – Mary, Joseph, shepherds, angels – but holds onto its aura of divinity, its miraculousness.

In the full picture of *Morning*, Runge gives the extracted baby a new context. He sets it in an elaborate and rather abstract mythological scene of his own devising, with a skyful of naked symbolic figures overhead. But when you see the fragment, it's clear that the new context isn't needed either. You need no more than the detail alone: a divine baby, taken out of Christian theology, and laid in nature.

All by itself, the little scene generates an elemental drama: a drama between earth below, and sky above, and human creature in between. Lying flat on its back on the world's flat surface, the baby is emphatically grounded,

under gravity. Facing and gazing straight upwards, it bathes in the morning light that falls from the sky – the sky off-picture, but strongly implied by the glow reflected on the baby's body. It opens its arms in welcome.

The new arrival is like a creature landed, fallen from the sky, an extraterrestrial materialising on an unpeopled earth. Equally, it's like a flower growing out of the fertile ground and opening to the sun. And because the fragment is tightly cropped, the whole picture belongs to the baby. It lies there, isolated from any wider human context, in a world of its own, the first child, a small thing but wholly self-sufficient.

The cut-out detail becomes an extraordinary image of new life, of pure beginning. The child's origins are made far more miraculous than those of the virgin-born Jesus – or of any normal baby, of course, with its mother and father, its genetic history and social setting. This fragment is a radical nativity scene that corresponds to our sense that every child (even if we have made it) is also a strangely new thing, original, individual, arriving out of nowhere.

Philipp Otto Runge (1777–1810) is best known for his portraits of children, terrifying little giants, bursting with chunky vitality. He was the most original of the German Romantic painters. In his short life he initiated a number of artistic projects that took off in the later nineteenth and twentieth centuries. He explored the growing forms of plants (in semi-abstract silhouettes) and the physics and symbolism of colours (devising the colour-sphere). In *The Times of Day* he envisaged the 'total work of art', a visual-verbal-musical-installation-experience, a dream that has inspired – in different ways – artists from Richard Wagner to Mark Rothko and still hasn't quite lost its shine.

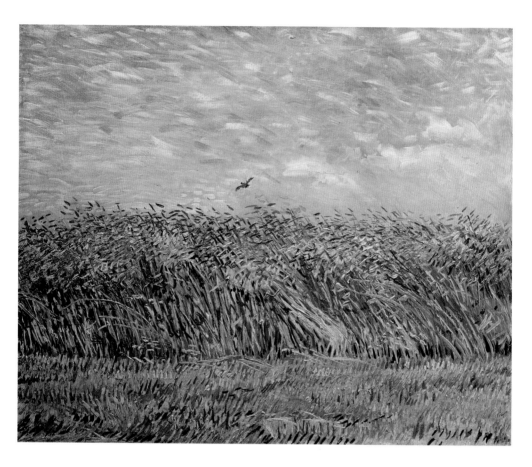

Wheatfield with Lark 1887
Oil on canvas, 54 x 65.5 cm
Van Gogh Museum, Amsterdam

VINCENT VAN GOGH

Sometimes in an art gallery you see a person holding up a thumb, at arm's length, between one eye (the other is closed) and a picture. What are they doing? They are blocking something out. They are trying to see what the picture would look like if a bit of it wasn't there. And why are they doing this? It's a test.

The picture has some questionable element, and the idea is to find out how things would work without it. You could be thinking: 'I wonder why the artist put that bush there; I'll block it out and see what difference its absence makes, and then maybe I'll understand why.' Or you could be thinking: 'I wonder why the picture feels so cramped, maybe it's the presence of that bush; I'll block it out and see.' Or you could be thinking: 'that bush, surely the picture would be better off without it; I'll check.' And the thumb goes up.

This practice certainly makes a kind of sense, when something in a picture puzzles you. But the method is imperfect. When you imagine an item removed from a picture, there's always the question of what you are going to put in its place. You can never just subtract a part from a painting. You have to fill it in. And your thumb-work will never tell you what the picture would look like *without* the questionable element, but *with* something else there instead.

OK, this is a matter of degree. Some things in some pictures are very hard to imagine away. They're densely bound up with the picture around them. Painting them out would require complicated reconstructive surgery. Sometimes, on the other hand, a pictorial excision is easy to envisage. The bit in question is distinct and separate and set against a plain background. Its removal is a simple pluck. It's obvious how you'd cover its absence. Sometimes, in fact, a picture has such a conspicuously extricable element, it almost invites you to imagine it gone.

Vincent Van Gogh's *Wheatfield with Lark* is a minimal scene. Van Gogh is seldom drawn to simple geometry and strict economy, but this picture is almost nothing but. It shows a view in three horizontal, parallel layers. We are at the edge of a field of still greenish, growing wheat, a few poppies among the blades. We're looking at where the sowing of the field abruptly stops, in a straight line. We're viewing the crops side-on, in cross-section so to speak.

The first and lowest layer is the unplanted foreground, which seems to be mainly old stubble. The second layer is the full height of the wheat. And the third layer is the open sky above it. The bands get wider as they go higher. They look as if they might be sized according to some calculation of proportion. At any rate, within the picture's frame, the design has a snug and solid feeling.

No prizes for spotting the extricable element. It is the lark. The little bird, fluttering in the sky above the surface of the corn, is the item that breaks the pattern, the bit that doesn't fit into the scheme. It's a single, small, isolated thing, set against a pretty uniform background. It's an obvious potential extraction. It wouldn't leave a big hole, and there's no difficulty seeing how its place would be filled – just add more sky. Put your thumb over it: *Wheatfield without Lark* is easy to imagine.

Now you may feel that the picture is damaged by the loss of lark. Perhaps the pattern needs this pictorial grace note to bring it to life. Certainly, the small deletion makes a big difference. Larkless, it is a changed scene. The whole emphasis shifts. Without the flying bird as the centre of action, you notice far more strongly the motion of the corn itself, blowing wildly in the wind. Before, there was a visual drama between the solitary dancing lark-speck and the expanse of wheat. Now, the visual drama is all in the wheat, in the way it stirs restlessly against its regular horizontal shape. Of course, even with the lark, the windiness was clear, the bird is blown around in it too. But without the lark, it's the tension between geometry and turbulence that becomes the scene's dominant effect.

Wheatfield without Lark is not a bad picture. You may even prefer it. For what does the little bird add? Isn't it just a gratuitous nudge, a bit of heightening, a kind of emotional punchline or focal point, put in to precipitate the contained feeling of the scene? *Ah, the lark – spinning in the air!* Ping! Maybe the scene is more powerful, more concentrated, less manipulative, less sentimental, without its lark – when it's just saying *the wind in the corn, the corn in the wind,* conveying the continuous, driven, buffeted threshing of the crop.

Not so fast, though. Don't ignore the picture's big dichotomy. What the

cross-section composition makes so clear is the division between matter and void, between the ground with its crops, and the empty air above. Without the lark, this contrast is weakened: the air needs something in it, to make you feel its emptiness. And notice how the lark is not just an extricable element, but a free element. Van Gogh could have placed this flying speck at any point within his rectangle of sky. No doubt he found exactly the right place for it – hovering, just off-centre, just above the wheat. But the fact that (realistically) the lark could go anywhere only re-emphasises the air as a free and open area.

Or *did* he find exactly the right place? A little work with scissors and crayon, and you could test that out too.

Vincent Van Gogh (1853–90) had such a short, prolific and rapidly changing art life that his pictures need to be dated, not year by year, but almost month by month. All his mature work, hundreds of paintings and countless drawings, is the product of his last five years. *Wheatfield with Lark* is 'middle period'. It was painted in the summer of 1887, during Van Gogh's crucial two-year stay in Paris (including some rural excursions). At this point he had absorbed Impressionism without yet becoming what he called 'an arbitrary colourist'. He left for Arles the following February. You probably know the rest.

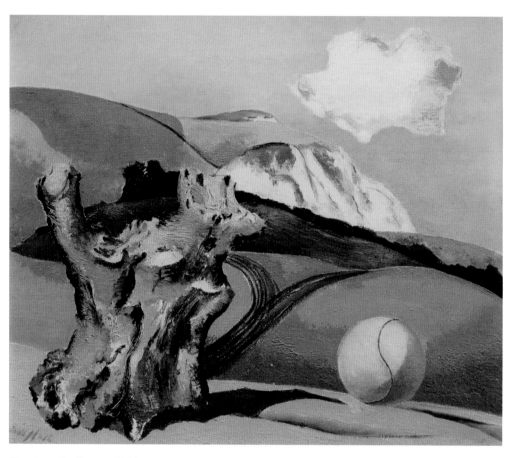

Event on the Downs 1934
Oil on canvas, 51 x 61 cm
Government Art Collection, UK

PAUL NASH

Some things are never funny, or so Henri Bergson maintained in *Le Rire*, his philosophical study of laughter. The natural world, for example, is inherently non-funny. 'The comic does not exist outside the pale of what is strictly human. A landscape may be beautiful, charming and sublime, or insignificant and ugly; it will never be laughable.'

It's a generalisation that invites contradiction. But the obvious counter-examples confirm Bergson's basic idea. A landscape garden could be laughable, but precisely because of the human input. A landscape painting could be laughable too, inadvertently or deliberately, for the same reason. Even a plain old bit of unmodified nature could be laughable, when in imagination we humanise it.

Nature often seems to wear something like a human face, which can also turn into a funny face. When you come across a broken tree, or a standing rock, it's common enough to see it as a kind of animate creature. Sometimes this gives the thing a solemn and mysterious presence. Sometimes the effect is funny. And sometimes there's a blend of both mystery and comedy in these transformations – and perhaps a doubt about whether you're laughing at nature, or nature is laughing at you.

Paul Nash's *Event on the Downs* is full of these mixed feelings. This picture is a bit funny, and a bit mysterious, and altogether a bit odd. The setting is somewhere in the south of England, but this isn't quite a landscape painting. It belongs to that small sub-genre, the landscape still life. It is a consciously Surreal image, with an incongruous juxtaposition of abruptly separate objects. It has mystical suggestions, with shades of Samuel Palmer and pagan spirituality. These downs are ancient British country, long barrow land. Just over the hill there might be a chalk figure, a circle of standing stones. But there's also a feeling of coast and sea, with the white cliffs and the ground falling away to the right.

The scene's protagonist is inanimate. An old gnarled stump of tree root stands stage front. It's a characterful object, a little creaturely, and the way that it's placed and singled out make it somehow significant. And then beside it – a tennis ball! It sits there like the root's daft sidekick, an all too human intrusion.

It pulls the scene away from deep nature and ancient henges, and into a Home Counties social world of country clubs, cocktails and dances. Though the poem was written a bit later, and set in non-pagan, non-coastal Surrey, this ball might have come bouncing in from John Betjeman's *A Subaltern's Love Song*:

Miss J. Hunter Dunn, Miss J. Hunter Dunn,
Furnish'd and burnish'd by Aldershot sun,
What strenuous singles we played after tea,
We in the tournament – you against me!

The tennis ball introduces a note of drawing room comedy. But it's not just a joke.

What is the 'event' in *Event on the Downs*? The picture is wide open to storytelling, sign-reading, echo-sounding. 'I was walking over the fields, and suddenly in my path there was this weird tree root.' Or: 'I was looking for my lost ball, and there it was, sitting next to this weird tree root. It was as if it had been put there. It was as if they were sitting there together, waiting for me. It was rather spooky. I almost laughed.' In a way, the picture presents a realistic situation. Nature and chance do sometimes contrive these strange meetings for us, these discoveries that feel meant – part-numinous, part-funny. And then, for good measure, the picture arranges some extra levels of resonance.

Notice the groove on the tennis ball. It falls into a perfect S, and gives the ball the form of the Chinese yin-yang symbol. It is like a winding path too, and echoes the curving Y-shaped paths that lead over the field into the distance. And how big is this ball, actually? The picture gives a very unclear sense of the scale of things. If the tennis ball was normal size, that would make the tree root tiny. But surely the tree root is not tiny. So is the tennis ball enormous?

Or look at the lonely cloud, hovering above the cliff. It appears pretty rock-like itself. Several Nash pictures of this time depict standing stones – and they're rendered in exactly the same way as this cloud is. His pictures often have moons too, white discs in a day- or night-time sky. This picture has

neither stones nor moons. But isn't the cloud really a floating megalith? Isn't the tennis ball, directly beneath it, with its crescent of shadow, really a landed moon? Haven't sky and ground just swapped places?

You can notice all these things. But noticing them won't tell you what they're supposed to add up to. Perhaps you're a visionary, having a revelation of mystical correspondences in the natural world. Or perhaps you're a member of the Famous Five, scouring the countryside for clues to a non-existent mystery.

Event on the Downs tells nothing, that's its secret. It has a perfectly sceptical view, not believing or unbelieving. It's full of hints of meaningfulness, clues and signs and connections. It lays them out pat before you, to be picked up if you wish, or to be dropped dead. It assumes that the world and the human mind are such that strange presentiments are likely to arise, but it makes no further claims, either positive or negative. Here is a curious tree root. Here is a lost tennis ball. Here is a world around them, loaded with reverberations that could mean anything or nothing. It's a funny landscape: funny, because it leaves the viewer quite stumped.

Paul Nash (1889–1946) had one of the rarest imaginations of twentieth-century British painters. He was first and last a landscape painter, a believer in *place* through all his transformations. He worked as a First World War artist, producing the classic image of shell-torn terrain, *We Are Making a New World*. He experimented with abstraction, and dallied with Surrealism, and made symbolic-supernatural images of megaliths, equinoxes and flying sunflowers. Shattered or snug or weird, Nash's nature is animistic, with rocks and hills and trees presented as semi-animate creatures. The artist was always in two minds about modernity, but the advance of motor tourism was unstoppable; in 1935, commissioned by John Betjeman, he wrote the *Shell Guide to Dorset*.

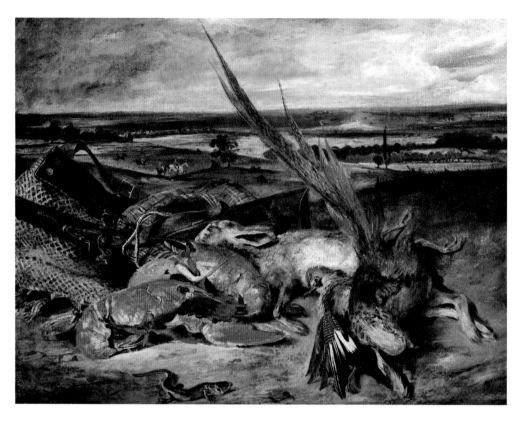

Still Life with Lobsters 1827
Oil on canvas, 80.5 x 106.5 cm
Louvre, Paris

EUGÈNE DELACROIX

Lobster. Lobster, lobster, lobster, lobster, lobster. There is a phenomenon known to most language users: a word is repeated too often, and loses its meaning. It gets stranded and estranged, becoming a pure or empty sound. Lobster, lobster, lobster, lobster, lobster. The name given to this in cognitive science is 'semantic satiation' or 'semantic saturation'. That describes the cause. The effect is semantic evacuation. But it need not only afflict words. Images and things too can be evacuated of their meanings. Lobster, lobster, lobster, lobster, lobster.

The lobster is strange anyway, famous for it. It's a mascot-beast of Surrealism, but long before it was surrealised, this marine arthropod was recognised as weird. It's aquatic but not remotely fishlike. It's a living creature whose surface is hard, shiny and dead as ceramic. In art it has often cut an incongruous figure. Two of them make a notably bizarre appearance in a picture painted by Eugène Delacroix, *Still Life with Lobsters*.

Even without the lobsters, this is a strange, borderline work. It shows a view of fields stretching to the horizon. Its main subject is a pile of lifeless eatables. In other words, the picture belongs to that hybrid genre, the landscape still life. A group of foodstuffs is assembled, not on a kitchen table, but on the ground somewhere in open country.

The landscape still life always surprises. It puts fruit (say) in a place normally occupied by humans or living creatures. But it's not inherently incongruous. There can be an obvious enough link between the foreground subject and its background setting – the link between goods and the land that produces them.

Delacroix's picture suggests something like that. Some dead game lie in the foreground. Red-coated riders appear in the fields beyond. A sporting scene, then? But there's a misconnection. The game in question isn't huntsmen's quarry. The birds and the rabbit have been shot. Rifle and game bags lie amongst them. The huntsmen are in some other story.

These huntsmen in the landscape introduce a further twist to the genre. Painting traditionally ranks human over animal, and the living over the dead.

But this painting directly reverses these orders. It doesn't just put the inanimate in a dominant position. It visibly includes men and live horses, and relegates them to a background role.

What's more, the still life pile looks huge compared to the background. Of course it's supposed to be much nearer, and scale is part of any outdoor still life. But the scale here is out of control. We have no way to gauge the distance between the near mound and the far plain. We have no idea how big these lifeless things are. They could be enormous.

The picture casts its still life as if it were something much more than a bunch of equipment and small corpses. It might be a group of people sleeping, or dead human bodies on a battlefield. The tartan bag suggests clothing. The pheasant's wing, furled back so that its tip reaches the very top edge, becomes a framing device arcing over this group. It plays a role that in another picture might be taken by something much more substantial – a standard, a bending tree.

But then, for extra anomaly, there are the scarlet lobsters. They snuggle into the still life without any explanation. They are sea creatures among terrestrial game in the heart of the countryside. They are cooked food among raw corpses. How ever did they get there? Why? And what about – a final bit of gratuitous underlining – the little lizard that wiggles across the foreground?

By this point, the picture has abandoned all connections. The relationship between its component parts goes beyond mere incongruousness or reversal (which are only another form of order). There is simply nothing between the huntsmen and the boiled lobsters. There is nothing between them and the lizard.

Delacroix takes a structuralist approach to painting and to the world. A picture has a main subject, something big up front: a person, a vase of flowers, a building, a ship. A picture has a setting: a room, a landscape, sea, a tabletop, pitch darkness. It may have framing devices, like a curtain, a frond of tree, that make a bracket around the main subject. It may have a subsidiary subject, something smaller which acts as a foil to it, a role performed here by that lizard.

A picture is a set of functions, a series of boxes to be filled. The world is a supply of things and scenes with which to fill them, quite arbitrarily. The structure of *Still Life with Lobsters* is conventional, but its contents are random. 'Nature is a dictionary,' Delacroix said, 'one draws words from it.' They become like words that have been vacated of meaning, retaining their sounds alone.

Lobsters, bags, guns, birds, rabbit, lizard: they lose their sense. These things are alienated from their creaturely lives and from human values. They become existentially null, the elements of a picture, objects, forms, reduced to their material beauties, their colours, patterns, sensations.

Red crustacean lies by green reptile. Flashes of plumage echo glimpse of tartan. Soft fur rubs against hard shell and rifle stock, against leather, gun metal, thick weave.

Eugène Delacroix (1798–1863) was a wild Romantic – and a highly self-conscious, calculating artist. He revelled in orientalist fantasy, in scenes of sensual indolence or deranged fanaticism. He painted lions and gypsies and crusaders, massacres and ecstasies, hunts and human sacrifice. *Liberty Leading the People* is the great icon of revolution. *The Death of Sardanapalus* is an orgy of destruction. But he always knew what he was up to. He was an assiduous analyser of colour. His famous *Journals* are full of tips about technique and effect: 'The first virtue of a painting is to be a feast for the eyes.' 'One always has to spoil a picture a little bit, in order to finish it.'

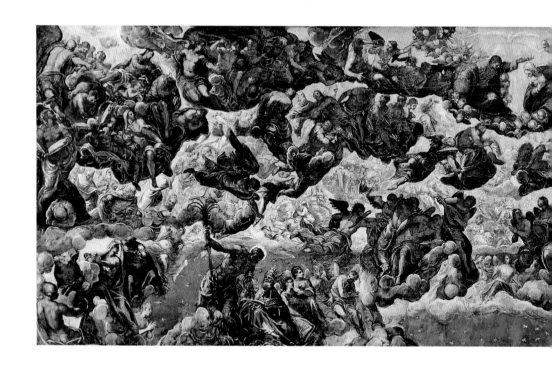

JACOPO TINTORETTO

Towards the end of Samuel Beckett's novel *Molloy*, the narrator poses 'certain questions of a theological nature'. The numbered list includes puzzlers like: '3. Did Mary conceive through the ear, as Augustine and Adobard assert? . . . 7. Does nature observe the Sabbath? 8. Is it true that the devils do not feel the pains of hell? . . . 11. What is one to think of the excommunication of vermin in the sixteenth century? . . . 13. What was God doing with himself before the creation? 14. Might not the beatific vision become a source of boredom, in the long run?'

Here, as elsewhere, Beckett delights in the more far-fetched points of Christian doctrine. The questions may sound bizarre and abstruse; all of them have at some time been asked and answered and argued by a Doctor of the Church. One of them, though, also strikes a common chord. It is normal enough to wonder whether heaven, if you got there, wouldn't be a bit dull. Not that you'd want to go to hell, but still, utter, unrelieved and unvarying bliss, it could

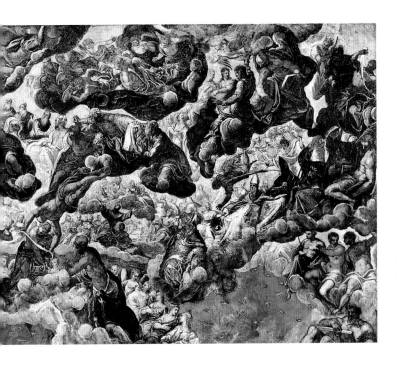

*Paradise c.*1580
Oil on canvas,
169.5 x 494 cm
Thyssen-Bornemisza
Collection, Madrid

pall, no? Or as Beckett phrases it, with an air of exquisite tact, not wanting to hurt any feelings or jump to any conclusions, but still, 'Might not the beatific vision become a source of boredom, in the long run?'

Theologians might reply that this is really a problem of the human imagination. From our limited mortal perspective, we can't help equating the eternal with the interminable. We just can't conceive, till we experience them, the joys of foreverness. Maybe so. But for artists it is also practical problem. They have, from time to time, had to represent heaven. They want to make it look at least tolerable. The human imagination is all they've got to work with.

And their visualisations have not always been encouraging. The image of the highest heaven is so often a matter of bright lights and concentric rings. The hosts of heaven are arrayed in tiers around the shining godhead. Sometimes they assemble in full circles with God at the very centre of the target. Sometimes

they assume an amphitheatre formation around God at the top. In other words, they end up with a composition that's symmetrical, stable and repetitive to the highest degree. The pursuit of perfection has achieved perfect pictorial tedium, which is exactly what one might fear.

This picture of *Paradise*, by Jacopo Tintoretto, is the great exception. It is filled with clouds and crowds of airborne figures in the traditional manner, but it's a rare case of a non-boring vision of heaven. It's not an exhibition work. It's a painted sketch, submitted as a proposal by Tintoretto for a picture in the Ducal Palace in Venice. He won the commission. The resulting canvas is gigantic, one of the world's largest paintings, almost twenty-five metres across. It departs from the sketch in both shape and content. It's slightly less exciting.

The sketch is big enough though, almost five metres across. Its proportions are immediately dramatic. It has the format of a letter-box, with a width over three times its height. But even with such a panoramic scale, you have the impression that the image could continue further, going on off-picture, stretching wider still and wider. The reason is that it's a composition with no wings or bookends. This view of heaven stops where it crops, but there's nothing in it to put a limit to its sideways spread.

This heaven doesn't have a proper climax either. It has a sort of focal point – at the top, in the middle, the dove of the Holy Spirit hovers in the disc of light, and beneath that Jesus is crowning the Virgin Mary. But this isn't a centre around which the rest of the image radiates or circulates. Rather, the masses of floating figures and clouds are organised horizontally, into streams or bands that flow and meander across the scene – standing out darkly against a brighter background (made up of more massed figures and clouds).

The throngs of heaven, in other words, are not arrayed in concentric tiers around the Divine. Jesus and Mary don't have an especially privileged position: they're just incorporated into the highest stream. And all the streams of figures follow wavy trajectories whose twists and turns are unpredictable. The left side and the right side are loosely symmetrical, but don't mirror each other exactly. Nowhere does the scene settle into a regular pattern.

Nor do the bands themselves hold firm. Tintoretto's composition is fundamentally cellular. Each stream can be split up into separate clumps of figures, and these clumps can link up not only with the clumps next to them in the same stream, but also with clumps in the streams above and below. The formation becomes much more open and optional. Connections and relays can go off in all directions.

The whole scene is moving, too, but again it's indeterminate. Each clump of figures is in flight. The figure-streams seem to surge like storm water, or roll like a tornado, or explode outwards. But there are no fixed flight paths. The implied motion is changeable, multi-directional, readable in different ways.

It is a daring solution to the problem of heavenly boredom. It envisages eternity, not as permanent fixity, but as endless flux – turbulent, restless, unresolving, endless. Tintoretto's proposal is an exercise in pictorial chaos. The final work in the Ducal Palace retreats from this daring. It reverts to a more amphitheatre-like structure, with the heavenly choirs gathered in semi-circular tiers around the Jesus and Mary pair. The sketch itself points far ahead: to the all-over composition and free-form energies of Jackson Pollock's abstractions.

Jacopo Tintoretto (1518–94) was the leading Venetian painter of the later Renaissance, and his great works are still in Venice, especially the huge wall paintings in the Scuola di San Rocco. His real name was Robusti, but he was nicknamed after his father's trade, a dyer (tintore). In his work pictorial drama and disorientation often overwhelm legible subject matter. There are violent and obliquely plunging perspectives, and mixed-up scenery. Vivid metallic colours glare out. Figures are thrown into extravagant gestures. The brushwork dashes at top speed. Light and darkness fall in lightning flickers and sudden glooms. There's an atmosphere of hysteria. A Last Supper can feel like a train going into a tunnel.

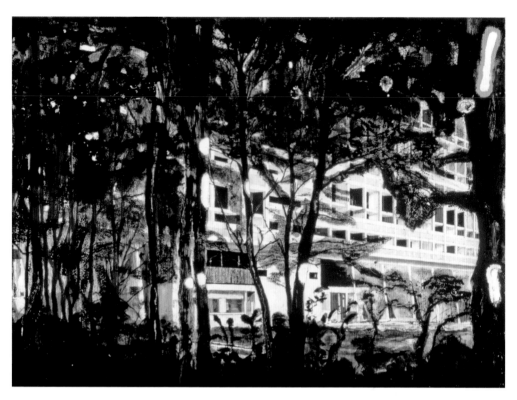

Concrete Cabin (West Side) 1993
Oil on canvas, 200 x 275 cm
Private collection

PETER DOIG

The English artist Walter Sickert told a story – a chestnut, he called it – about the work of the French Romantic painter, Eugène Delacroix. Some people were looking at a Delacroix picture, some extravagant and turbulent scene of Triumph or Plague or Massacre. But one of the figures in it, an old man, seemed utterly ambiguous.

The puzzle was which way the figure was shown – facing us, or from behind? It was impossible to discern. And so the question was referred to a well-known Delacroix fan. 'Which is it, you who are the greatest and most faithful of the master's admirers; back or front?' To which the enthusiast, through much agitation and confusion, replied: '*Monsieur, c'est ni l'un ni l'autre. C'est de la PEINTURE!*' Neither. It is PAINTING!

An unanswerable answer – also a little ambiguous itself. Perhaps the expert was just flannelling, avoiding the hard question with a reply that sounded arty and high-minded. We need not trouble ourselves about the 'this' and 'that' of imagery – a trivial and secondary matter, when the paint is laid on so magnificently.

Or perhaps he was saying something odder. Other things in the scene might be identifiable, standing for figures or bits of architecture or whatever. But as for this particular obscure passage: it meant nothing, it was just painting. In the midst of the busy scene, there was an isolated outbreak of pure *peinture*.

It sounds odd, yes. But whether or not it's something Delacroix does, it's the kind of thing that later painters have done. You find there comes a point in an otherwise representational image where the paint stops making sense. The picture changes tack, breaks down, takes off, and when you point to a piece of pigment and ask, 'what's *that* meant to mean?', there is no answer. It's a blip. It's what in information theory is called a piece of noise – a random or irregular disturbance which is not part of the signal or which interferes with the signal. The work of Peter Doig, for example, is full of noise.

Doig's *Concrete Cabin (West Side)* is a dense variation on one of the most basic pictorial games – the game of hide and peep. Something stands in front of something else, partially occluding it and partially disclosing it. In

such pictures, the stress may fall on the way things are frustratingly removed from our view, or on the way things are singled out for revelation. In *Concrete Cabin (West Side)* the emphasis is on revelation: suddenly, through the murky darkness, a fractured vision of bright architecture.

This is one of a series of works based on a true place, the habitation units designed by the Modernist architect Le Corbusier at Briey-en-Forêt. It is a bluntly two-layer scene, forest over building, and the surprising sight yields powerful contrasts: dark/light, nature/modernity, organic/geometry. The block, with its hard edges, white walls and squares of primary colour, breaks through the apertures of the wood in winks and flashes like a twentieth-century gingerbread house.

But alongside the glimpses of building, other bright marks stand out. There are those patches of blazing high white that appear on the trunks of the trees, the most visible ones being on the trunk at the right hand edge of the picture, with smaller ones on the trunks in the middle. You could read these as spots of dappled light coming through the forest. You could. But what they look like, if anything, is some kind of glare phenomenon, as if a light was pointed at you, or again as something burning through, as when a film gets stuck in the projector. In other words, these white patches aren't readable as anything in the scene before us. What are they? They're patches of pure *peinture*.

This turns out to be only the flagrant, announcing instance of an effect that, in smaller ways, is present all over the picture. Take those dots, dabs, slashes and flares of white and colour, scattered across the dark band of branches along the top of the picture. Some we can read as clear glimpses of the building beyond, some as very fragmentary and fuzzy glimpses. But some, again, are doubtful – more like little bursts of pure paint that just bloom among the foliage.

After that, these doubts begin to infiltrate everything. Wherever there's a fleck of brightness, a little flicker of uncertainty arises: picture, or just painting? And this isn't merely a device, it's a resource. Doig choreographs and paces these points of slippage among the more or less identifiable glimpses. As

noise and signal switch and blur and jostle, he sets the whole canvas buzzing with visual doubt and activity.

Peter Doig (born 1959) is a mobile artist: born in Scotland, raised in Canada, trained in London, now living in Trinidad. His paintings first appeared when talk of the Death of Painting was at its loudest. He paints with sophistication but intuitively, without irony or tricks. He has called his pictures 'abstractions of memories'. They are often landscapes, sometimes with figures – a solitary house, a river in a forest, a snowscape – and always derived from photographs or film stills. The scenes suggest fixation, sights that have somehow got stuck in the mind, a trauma, a moment of 'Rosebud' ecstasy, a memory frozen – and then treated, by being overlaid, obscured, disintegrated, illuminated with intense decoration, networks of branches, blizzards of snow, strange meltings and corrosions of the paint.

Study of Clouds 1822
Oil on paper, 48 x 59 cm
Ashmolean Museum, University of Oxford

JOHN CONSTABLE

Clouds are all sorts. They are a medium of revelation, through which the gods show themselves. They're a playground for human imagination, where we can see any number of forms and creatures. They are mood music, the emotional backdrop to a scene. They are complex natural phenomena, which challenge our capacity for accurate observation.

Artists are free to take clouds and mould them as they will, into celestial signs, or surprising animals, or expressive abstractions. But the discovery in the late eighteenth century that clouds are not an infinitely mutable fluff, that they come in types – cumulus, stratus, cirrus, nimbus – checked that freedom. If clouds are pure formlessness we can do what we like with them. If they have fixed identities they may resist our shaping.

This *Study of Clouds* by John Constable claims a strictly observational status. His vantage point is Hampstead Heath. The canvas is marked on the back: '31st Sepr 10–11 o'clock morning looking Eastward a gentle wind to the East.' Still, the painting itself may leave you wondering what kind of formation you're looking at.

Seen one way, this cloud mass declares a distinct shapeliness. It has a linear structure. Within its clumpiness, you can discern an arrangement of straight lines, diagonals and parallels and intersections and enclosures. It's formed like a graphic symbol or a Chinese pictogram. It could be drawn out in bold simple marks.

It's a shape that looks like something designed, a kind of skywriting. And given that these are clouds, with their ancient supernatural associations, this pattern may suggest, subliminally, a sign or a message forming in the heavens.

Subliminally. But then, the whole effect remains very subliminal. A shape can be detected, yes; but it's sufficiently diffuse, on the verge of unforming, to keep you in uncertainty about whether it's really there at all.

Dabs of painted cloud build up, but where do they conclusively *group*? At every point what might be a coordinated design might equally be a loose, unplanned gathering. A deliberate scheme is possible. A pattern is never definite and decided enough to be certain.

The structure is so elusive that it might have arrived with no deliberate shaping, through an automatic process. Perhaps it appears in the painting simply because it appeared in the sky. Constable transcribed it with unblinking, unmanipulating accuracy from an actual ambiguous natural cloud formation that looked just like this. Or perhaps his image materialised on the canvas through an act of unconscious, drifting painting, the artist's brush improvising, somnambulistically, with no comprehensive plan.

You can't be sure the artist was doing any designing. You can't be sure he was even aware of the quasi-pattern that was emerging through his hand. So Constable's own painting ends up like nature itself – a phenomenon like a cloud in which you can see shapes, but where no conscious shape-making has taken place.

Or if it's impossible to believe Constable was really unaware of his skywriting, you can see a more complicated kind of intention. He achieved this quasi-shapely cloud mass through a kind of refraining. He managed to paint it *as if* he wasn't creating it or noticing it, careful to keep his handiwork always indeterminate and undirected.

Five years before Constable made this study, at a house by the edge of Hampstead Heath, the poet John Keats was writing - in praise of a rare creative faculty. He called it, 'Negative Capability, that is, when man is capable of being in uncertainties, Mysteries, doubts without any irritable reaching after fact & reason.' It happens when artists know how to stay back, leaving their work open, unsolved, holding unknowns. If you want to know what negative capability looks like in paint, it looks like this.

John Constable (1776–1837) painted, according to a recent poll, Britain's second favourite picture, *The Hay-Wain*. His murky, flecky paint-world is not a favourite with all of us, but its power can be acknowledged – the unprecedented *atmospheres*, the way he can bring the outdoors into a picture gallery, get paint to convey sunlight and open air and wet and wind and breathing vegetation and spreading distance. As Fuseli said, 'he makes me call for my great coat and umbrella' and the illusion of deep receding spaces in his *Salisbury Cathedral* in the National Gallery in London is astonishing. But there is another side to him, the conceptual Constable, whose power is in his play with pictorial convention, with what counts as a subject for a picture – who fills the frame with just a long shot of clouds, or with a single up-front tree trunk.

Sand Dune 1983
Oil on canvas, 198 x 147.5 cm
Fondation Beyeler, Riehen, Basel

FRANCIS BACON

W.H. Auden's lines make a clear announcement. 'To me Art's subject is the human clay, / And landscape but a background to a torso . . .' It's a manifesto. Humanity, he wants to say, is the primary thing in Art. Everything else takes second place. Or so it seems.

The words he actually chooses are not so sure. The human clay? The words could let our imaginations run, taking us into strange regions of flesh and matter and flux. Auden envisages perhaps a little moulding, and a little baking, producing a safe and separate figure, and that's all.

Clay, though, is a very malleable and transformative medium. It is wet. It squashes. It has no limits. It comes from the earth and can be pressed back into the earth. And so the distinction that Auden strictly draws between a torso and a landscape is only relative. Body and ground can easily merge.

Look at paintings. Landscapes and nudes often lie down together. The rolling hills and the curving limbs can join in harmony, or fuse into something even closer. There is view of a coast by Degas, for example, where the shapes of the grassy terrain are also clearly the emerging forms of a naked woman on her back. And this Degas is probably an inspiration to a painting made almost a century later. Here the medium is a different stuff: human sand.

Francis Bacon's *Sand Dune* isn't exactly a landscape. It is a heap and a slide of sand, an extract of the outside, perhaps from the seaside, perhaps from a building site, but now it's been taken inside and put on stage. The scene has various stagey devices often used by the artist: a glass chamber, a hanging light bulb, a pointing arrow, a disc of blue spotlight on the floor, a dark suggestion of a shadow or a leak.

On this stage, the volume of sand has a weird physical presence. It is partly contained within the tank and partly spilling out and through the sides of the tank, and most of it seems to be viewed as if in a three-dimensional magnifying chamber, so when it appears outside (at the right) it visually shrinks. The bright blue screen at the back is sky, another extract of outdoors, or a screen projection.

But the sand dune itself is obviously the protagonist. You could call it a

thing. You could call it stuff. It's certainly the subject. And unlike many of Bacon's subjects, bodies or heads, this one retains its integrity. Its form is not radically distorted or disrupted or dematerialised. This dune is a solid, continuous mass.

It is sand; but of course not only sand. It is also flesh, a pure flesh. This flesh has no rigidity, no internal structure, no tension, no action. It is simply a contour of skin, containing a soft blob. It lies, lolls in itself, it has sinkings and swellings, it rolls in indolence, melding into a single flow. It might be the fattest person in the world who has lost all parts.

Or rather, not quite. It is like pure flesh but it also has hints of a creature within it too. An anatomy exists, just about. There are buttocks rising, a bending left knee sticks out at the front, a right thigh is stretched out, even a shoulder and an elbow become visible. As you look more closely, this figure appears, face down, stirring like mounds from the sand, like somebody covered in sand, or made loosely from sand.

Ambiguities arise. This mass is uncertain between anatomy and sheer flesh, uncertain between flesh and various other substances, which could be powder or liquid or pulp. Sand itself is well chosen and imagined. It's an intermediate stuff that can be dry and pulverised, or a running, pourable fluid, or a quite compacted, malleable paste, like clay.

Sand Dune is in metamorphosis, in a calm hysteria. It's an entity that can come half alive and enjoy feelings. It can be picked up by the shovelful. It can be stroked and smoothed. It can cascade. It can be dispersed and lose all sense of limits. At different points around the dune, these different sensations come to the fore. There are even moments when it seems like dust in air.

And then at the crest of the dune there is something like a tuft of rough grass, or a crop of hair. It comes to the vestigial beginning of a head – a final intimation of the human about to break the surface.

Francis Bacon (1909–92) used to be seen as a nightmare visionary. His Screaming Popes and Crucifixions were horror shows. But this drinking, gambling, Soho bohemian was also a performer. His colours are gorgeous. His lines have cartoon bounce. His paintings look less blood-curdling – and more sumptuous, energetic, graceful, playful, even jolly.

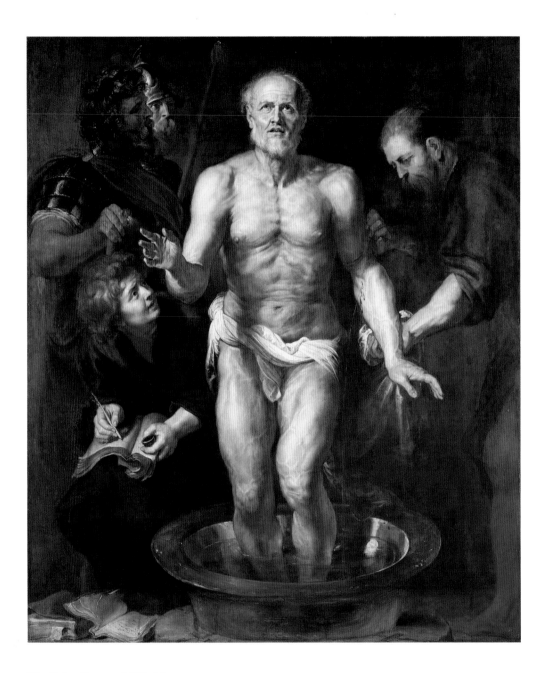

The Dying Seneca 1612–13
Oil on canvas, 185 x 154.7 cm
Alte Pinakothek, Munich

PETER PAUL RUBENS

On 11 June 1963, at a crossroads in Saigon, the Buddhist monk Thich Quang Duc burned himself alive in protest against the government's persecution of Buddhists. Journalists present took a sequence of photographs, which have preserved the event in collective memory.

You see the monk seated on the ground in the lotus position as petrol is poured over his head. You see his body engulfed in the first explosion of fire (he had dropped the match himself). You see his blackened form continuing to maintain its position while the flames burn on. You see his body, now dead or unconscious, finally falling over backwards to the ground. As one eyewitness observed: 'As he burned he never moved a muscle, never uttered a sound . . .'

There's something peculiarly horrible and frightening about these pictures. It is more than simply the opportunity they offer for imagining extreme and mortal agony. It is probably a combination of two things: the making of an agonising death into a public performance, together with the monk's perfect composure under overwhelming physical affliction.

Both these things offend against deep feelings. Savage pain should not be formally exhibited in a public place as a form of theatre. And while physical courage and spiritual discipline may be admirable, people should not be able to detach themselves utterly from their own bodies and fates – beyond a certain level, endurance becomes inhuman, obscene.

These feelings, though deep, are perhaps culturally local. Public executions of the most revolting nature were once common enough in Europe and elsewhere. They certainly made bodily torment into theatre, and people certainly watched, not always in grief and horror.

A similar question arises with old master paintings. They frequently depict the most terrible physical torment, but it is often hard to tell how shocking they find it. With Christ on the cross and the Christian martyrs, the idea is that the victim exhibits perfect obedience to the pain inflicted, but this is often so perfect that it is hard to distinguish it from a kind of supernatural anaesthesia. With other sufferers, like the damned in the Christian hell, their torments are made so visible that the agony becomes a kind of performance in itself, something

the figure is expressing rather than undergoing, a grand act of writhing and yelling.

It's quite rare, in fact, to find an old master painting that can make you really feel the fact of affliction – feel the difference between a human individual and the fate that has befallen him or her. But Rubens' *The Dying Seneca* is a painting that can. It is a scene of self-inflicted public death, and it makes affliction vivid through the sufferer's own alarming detachment from it.

The Stoic philosopher Seneca was famous for his suicide in AD65. He had been the Emperor Nero's tutor. When the Emperor went bad, Seneca's time was up. Rather than suffer execution, he took the dignified Roman way out. The historian Tacitus says that the old man's blood flowed too slowly, and he had to hasten his death with first poison (which didn't work), then a hot bath, whose steam suffocated him.

Rubens' picture holds no hint of these complications. *The Dying Seneca* implies a smoothish end. The philosopher stands in his bath, among friends, with his veins being opened. He is cast as a noble non-Christian martyr, putting Stoicism into direct action. But for that reason, the painting becomes shocking. Bodily death is accompanied by overt self-control and self-display. What's more, this shock seems to be a deliberate effect. In several places Rubens emphatically mixes up dignity with helplessness, formality with weakness.

Rubens is proverbial as a celebrator of the fat body, male as well as female. The philosopher's body is strong and muscled, recognisably a version of the heroic body so familiar in post-Renaissance art. His head is held upright. But the lower half of this figure is beginning to crumple, his bottom going out, his knees sinking, in a most unheroic manner.

His lack of clothes is ambiguous. It could be self-sufficient classical nudity, or the exposed nakedness of an old man in the bathroom. And the nature of the bath itself is strangely compromising. It's as if his powerful body is stuck to a base, helpless to walk or control its balance.

He performs. He addresses the viewer, his body turned directly to face the front. His eyes don't meet ours, they are lifted up, to convey an elevated state

of mind, but he is in mid-speech, with a raised rhetorical hand. Everything indicates consciousness of a public role to be visibly played. But at the same time, and no less visibly, he is dying, the lifeblood dribbling into the bathwater from the veins in his forearm.

Speechifying and dying. The two attendants at either side of him embody these divided aspects. One is a secretary, pen poised, taking down Seneca's deliberately delivered last statement (he has written the letters *vir* . . . it's going to be something about virtue). The other is the surgeon who has opened the vein and is letting the blood. Both men are steadily *attending* to the philosopher's dying body, with no more compunction than a pair of tailors measuring a man for a suit.

What's troubling in the painting is the way it conveys a complete distance between the self, the publicly performing self, and the physically dying body. The philosopher's sturdy body, which dominates the picture, is a mere organism or mechanism – not *him*, not anything to which he is especially attached. If the man were violently sliced open, and howling in agony, the picture would be less horrible. But here he stands and spouts, rising above his flesh, which another man is employed to close down, not savagely but with calm efficiency, with the discreet operation of a tourniquet. Two soldiers witness with admiration the unnerving spectacle: the body of a disembodied mind.

Peter Paul Rubens (1577–1640) was the ultimate pro: painter, scholar, courtier, roving ambassador for Flanders to the courts of Europe. To modern eyes, he seems a strange kind of genius – unshadowed. His career proceeds without setback or conflict, doubt or torment. His work has no secrets, subtext, angst. He is gloriously confident, infinitely capable, effortlessly triumphant, master of every genre (except still life). He was not modest. 'My talents are such,' he declared, 'that I have never lacked courage to undertake any design, however vast in size or diverse in subject.'

The Burden c.1865
Oil on canvas, 116.3 x 89.2 cm
Private collection

HONORÉ DAUMIER

Here's an exercise for you. Take off your clothes. (Optional, but it will make things clearer.) Stand before a large full-length mirror. Make sure there's a darker or paler wall behind you, so your body stands out against it. Strike a pose, nothing too difficult, a pose you can hold. Hold it, stock still. Notice the shape that your body makes. Notice especially its outside edge, its contour.

Now ask a friend to take a marker-pen, and draw a line onto your body that follows this contour, tracing the very edge of your body shape as it appears in the mirror. When that's done, there should be a barely perceptible outline going all the way round you. However, this task will prove almost impossible.

It is almost impossible, partly because your friend will have to do it all under your guidance, since you alone can see the particular outline in question; and partly because the edge of your body, though it may look clear in the mirror, will turn out to follow a very erratic three-dimensional path over your body surface.

This outline will swerve back and forth as it crests the body's hills. It will jump between one body part and another. If you imagine the route of your contour as a wire construction in space, it would be a meandering, zigzagging and (from most viewpoints) meaningless configuration.

Yes, there are some things – a head seen in perfect profile, say – whose outline will lie almost entirely on a single flat plane, just like an outline in a picture. But most positions the human body can get itself into, viewed from most angles, will yield a countour that goes all over the place.

The lesson of this exercise is that shapes are strange entities. In pictures, they can look very plain, with every object bounded by a definite and continuous contour (and perhaps an actual outline tracing this contour). In three-dimensional reality such simple boundaries don't exist. Our contours are chaotic. When someone's looking at you, you've little idea where your visual edges are. You may be very conscious of your figure, but you aren't a cardboard cut-out. Exactly where your body's contours lie is not something you can be aware of. (Another exercise: stand in front of someone and try guessing.)

But figures in pictures are stranger still. They don't just have simple contours.

Sometimes they seem to experience their contours – to be *physically* enclosed and bounded by them, as by an encasing mould. The figure feels confined, or fortified, or squeezed, or supported, within the shape its body makes. This is of course a completely fictional dimension of experience. It only happens in pictures. There is nothing in our three-dimensional lives that corresponds to it. The visual shapes our bodies make cannot physically impinge on us. Yet in the pictured world, the laws of nature change. The shapes of things exert a powerful hold. Look at the work of Daumier.

Honoré Daumier has been praised for showing, not what people look like, but what they feel like. He's not alone in that. The same compliment has been paid to Michelangelo and to Picasso and to the cartoonist H.M. Bateman. The depiction of physical sensation is something that cartoons, still or animated, are especially good at. (It is practically the whole point of Tom & Jerry.) Daumier was partly a cartoonist, partly a painter, sometimes a bit of both. It's no surprise to find that feelings are his forte.

Often he paints figures who are entirely given over to bodily sensation. They race through the air. They are slumped in exhaustion. They wrestle. They're towing a barge or struggling with a weight. Their feelings subsume them, and their shapes embody these feelings.

Daumier painted this picture, called either *The Burden* or *The Washerwoman*, in several versions. The basic motif is the same in each: a woman is lugging a heavy basket of washing down the street, with a little child toddling beside her. Her strain is palpable. She is bending against the weight of her load, while pushing against an impeding wind. And so great is the sense of effort, you could believe she was tugging a barge too. She seems to be moving with the kind of motion you get in dreams, where you walk and make no headway at all. And this is not in fact the most agonised version of the image.

But it is the most shape-conscious, and shape is where its power lies. The woman and her burden make a firmly contoured and outlined shape, with several sub-shapes inside it. These shapes are clear; more than that, they have a strong identity in their own right, so that they are in tension with the natural

shapes of her body. Her pictorial shaping applies a pressure, a bondage to her anatomy. It enacts and aggravates her bodily strain. These shapes are what make the figure's sensations so palpable.

Her contours hold her down, forcing her body against its human uprightness. The top edge of the figure, from laundry to head, bonds it into three climbing steps. The shoulder, the focus of her labour, juts up in a rounded right-angled hump. The face and neck, as they push forward, are drawn out into a pink phallus. The top edge of her face, and the contour of her shoulder, lie in an almost straight horizontal line, fixing the head low and rigid. Her right arm is pulled round into a curving hoop.

In the process, of course, there is distortion. The body is not just bound by its shapes into its strenuous position. It is reshaped to fit in with them. It is moulded to its exertions. It becomes a body that's hard to imagine ever straightening up, or doing anything else. It lives only in this form, in these contours, in this labour, like one of the damned.

Honoré Daumier (1808–79) was the most singular figure in nineteenth-century French art. He was the age's greatest caricaturist, an outspoken social satirist, scourge of the bourgeoisie, a public voice for Republicanism. At the same time, and far more low-profile, he was a radically experimental painter, whose free shape-making and brushwork were admired by Delacroix and Degas. And in his grotesque clay figurines of French politicians he was also one of the most original sculptors of the century. The subject of his tragic-comic art is always the human body, its exaltations and oppressions. We'll never see anything like him again.

Combing the Hair 1896–1900
Oil on canvas, 82 x 97 cm
National Gallery, Oslo

EDGAR DEGAS

About fifteen years ago there was an exhibition of late Degas works in London, and on TV the poet and critic Tom Paulin reacted. He had strong views about how the artist pictured women. He said: 'They're like performing animals, they're like animals performing in the zoo. There's some deep, deep hatred of women . . . I think it's coded. Basically what he's thinking about is women on the loo, and I think that is his eroticism. He's an old tit-and-bum man. A woman wiping herself – I kept thinking, what would children think of this? – a woman wiping herself, it goes on and on.'

It was a stirring indictment, and in a way quite right. If you take Paulin's words *against* the spirit of their feverish moralism, then they're extremely acute. Take away the puritan body horror, take away the assumption that Degas lip-smackingly shares this body horror, take away the idea that the most revolting thing you can do to somebody is to imagine them on the loo, and you have a good insight here into Degas' late work.

It is just the kind of subject he might have done. It's a pity he never got round to doing it. He would probably have done it well. His great theme is human beings struggling with their own embodiment, with the fact that they have bodies. Going to the lavatory, that strenuous bodily imperative, would be an excellent case in point. Degas is not very horrified by such things. (Come to that – 'what would children think of this?' – nor are most children.) He isn't exactly turned on by them, either. His work at this stage is less about looking at bodies, more about imagining how they feel.

Degas never depicted a woman on the toilet. He often depicted a woman 'at her toilet', to use the antique phrase. There are many images of a woman washing herself, drying herself, wiping herself – not actually wiping her bottom, but not far off, and presumably that's what inspired Paulin's thought.

The human arm is generally just long enough to reach the human bottom. Perhaps this is an evolutionary consideration. It's certainly the sort of consideration that animates Degas' images. He concentrates on the limits of the body's self-management. He shows how a woman drying herself can only just get a towel to between her shoulder blades, and half-nelsons herself

in the act. He shows how drying the sole of a foot can put the body's whole balance at risk.

The body in these pictures is not an angelic body, an unresisting and infinitely flexible instrument of the will. It is an obstacle, an impediment. And there are Degas' pictures that pick on other awkward aspects of having a body – for example, our hair.

Our head hair. It is a strange thing, head hair, or a strange body-part, and the question of whether you'd call it a thing or a body-part is what makes it strange. It's an inanimate stuff to which we're very intimately attached. It has no sensation itself, it is biologically dead, but when you pull it, don't you know it. Unlike body hair and animal fur, our head hair can grow to an indefinite length; and when long it becomes a distinct entity, a lifeless extension of the living body, a reminder that we human creatures are inextricably a part of matter.

A blazing red-orange lump of the stuff is at the heart of Degas' *Combing the Hair*. It's the climactic colour point in this scene of whites, blacks, browns, buffs, pinks. A woman is sitting on a bed. She holds her head bent over sideways so that it's lower than her shoulders. Another woman stands a little away, her own head slightly bent and her face out of sight. Between the two of them stretches the long mass of hair. They're both holding onto it, one in cagey self-protection, the other in the act of combing it out.

It's true of course that this hair belongs to one of them, and doesn't belong to the other. But the way the picture shows it, it's more like a separate object that's being negotiated between them. The hair may be physically attached to the head of the first woman, but it seems to be attached like a thorn or splinter, some foreign body, in the process of being carefully but firmly dealt with. We're conscious, too, of how sensitively embedded it is – a piece of flaccid matter, but rooted in its owner's head. And how tenderly the sitting woman puts her hand to those roots, to regulate the painful tug of the combing. How gracefully she submits.

The head, yes, the top body-part, is where this dead stuff grows, and provides a handle for the body. There's a particular helplessness in having your hair

pulled, or being pulled around by your hair, like the cartoon caveman's wife. And this woman here, having her hair combed, is bowed down by this, in her bent-right-over-sideways pose, with the line of the neck becoming continuous with the line of the shoulder. In that total head-down, she bows before the inevitable fact of her embodiment.

Proust said: 'It is in moments of illness that we are compelled to recognise that we live not alone but chained to a creature of a different kingdom, whole worlds apart, who has no knowledge of us and by whom it is impossible to make ourselves understood: our body.' It is not only in moments of illness. It is everyday, several times a day, when we comb our hair, when we dry our backs, when we wipe our bottoms. I hope no children are reading this, but those are the facts of life.

Edgar Degas (1834–1917) has become a problem these days, a happy hunting ground for bad attitudes. Once he was lovable, the Impressionist of human action, doing race meetings in bright livery and blur, graceful ballerinas on the hop in a flourish of glowing tutus, spontaneous accidental-looking scenes. But the stress has shifted onto his voyeurism and his sexism, his treatment of women as zoological specimens, the artist as bachelor-misogynist. Some sense in that: in Degas' work, humans are emphatically not angels, and women are the prime exhibits of his mixed feelings about bodies. But for making a drama out of the body itself, he is the modern Michelangelo. His small clay working models of dancers and bathers, cast in bronze after his death, are the greatest sculptures of the nineteenth century.

Water Nymphs 1899
Oil on canvas, 82 x 52 cm
Zentralsparkasse der Gemeinde Wien, Vienna

GUSTAV KLIMT

The ears of Mickey Mouse are a good lesson in two-dimensionality. Mickey's ears are simply two black circles. That's how they first appeared in *Steamboat Willie*, in 1928, and that's mainly how they've stayed. There was a brief period in the 1940s when Disney experimented with more realistic ears, but soon they returned to their original form – two black circles attached to the top of his head.

The thing about these black circles is that they tell you nothing about the three-dimensional volume of Mickey's ears. You can see that, in some sense, they are round. But beyond that, you can read any solid form into them, or none. Are these ears meant to be flat discs? Or bowl-like concavities? Or spheres? No saying. They have an untranslatably two-dimensional existence.

The fact that Mickey is a moving image only makes this clearer. His body turns, and his head appears from different angles – profile, front, back, three-quarter. His head exists in three dimensions. You could make a model of it. Not so his ears. Whichever way Mickey's pointing, his ears always remain two black circles on top of his head with a gap between them.

Of course you *can* make a three-dimensional model of them. There are countless Mickey Mouse toys and costumes, complete with ears. But if you do, you yourself have to decide their three-dimensional form. The ears that appear in the films won't give you any help.

In general the question of their three-dimensional form simply doesn't arise. Looking at the cartoons, you don't feel puzzled by these blank black rounds. You don't wonder how exactly they would occupy space. You accept Mickey's ears in their sheer two-dimensionality. You find the same effect in paintings.

Gustav Klimt is the master here. He's a master at making shapes that, though they stand for some object, don't translate into a definite solid figure. And he takes advantage of our willingness to accept two-dimensionality, in order to create entirely non-specific bodies. This is the secret of Klimt's weirdly dematerialised physicality.

Look at his most famous painting, *The Kiss*. The embracing couple are enveloped in an undulating shape, a mass of patterning and gold leaf. People

often talk about the opulently decorative surfaces in Klimt's pictures, and that's right. But equally important is the question – the usually unanswerable question – of what solid forms these flat surfaces hold. How would they body out?

In *The Kiss*, you read this gorgeous mass as standing for clothing, the man's robe and cloak, the woman's dress. Out of its folds their heads and hands emerge. But how exactly the rest of their bodies fills or occupies these garments is unknowable. Like Mickey's ears, this patterned shape tells you nothing about three-dimensional volume. It offers no clue to what's going on inside it. You're left to feel that the bodies somehow fill out and spread into this surrounding shape, and in the process dissolve into one another.

Or take a more bizarre creation, the picture called (variously) *Water Nymphs*, or *Silver Fish* or *Mermaids*. It is Klimt's strangest and richest sex-anxiety fantasy. These two bobbing underwater creatures apparently just consist of a head and a trail of long black hair. But their simple fluid forms are packed with queasy associations.

Any water nymphs in late-nineteenth-century art are going to have Wagner's Rhinemaidens somewhere behind them. But the Rhinemaidens have human bodies. Klimt's nymphs don't. They're a disturbing variation on the standard mermaid. The mermaid, with her long hair and fish tail, is here compacted into just a head with a hair-tail. This takes hair fetishism to its extreme, producing sex-objects with no limbs or bodies or even sex organs (apart from the mouth).

They could suggest decapitated heads, like the head of John the Baptist, or the head of Orpheus thrown in the river (both those legends involve murderous women). Or, more serenely, they echo traditional images of cherubs, who are pictured as disembodied heads with wings. Or, more malevolently, they're like traditional images of the serpent in Eden. The tempting snake coiling round the tree often has a human head.

Other images lurk in them. If you dwell on the idea of a woman who is all hair, there's the figure of Mary Magdalene, who went into the desert, and her head hair grew to cover her naked body: a wild woman who had previously

been a prostitute. Or there is the Romantic *femme fatale* with her luxuriant entangling tresses, and her ancestor Medusa.

If you look at the nymphs' silhouettes, they are clearly tadpoles or sperms. But if you look at their faces, and the way the hair hugs snugly around them, they're like smart ladies or streetwalkers in high-fur-collared winter coats.

Klimt compounds in this image an amazing repertoire of archetypes and stereotypes and uneasy sensations. They all focus on woman as sinuous seductress and snare, but they're full of contrary suggestions. In these figures you can see woman dressed up, a social spectacle – or woman as a raw blob of biology. The creatures could be both limply drifting like a jelly fish and lithely writhing like an octopus, something ungraspable and something that strangles. They are both female and male, angel and animal, victim and killer.

The reason *Water Nymphs* can carry such mixed associations is simple. These nymphs are like the ears of Mickey Mouse. They're dark flat shapes with no definite three-dimensional existence. They represent some kind of undulating body. But many kinds of solid volume, many kinds of substance, can be read into them.

They have fleshly faces, but what happens to that flesh when it disappears inside their hair? Is it a stream of empty floating hair, or a slithery reptilian tentacle? How would they feel? Soft or firm to the touch, passive or active, silky or slimy? The shapes tell you nothing. But they make you shudder to think.

Gustav Klimt (1862–1918) specialised in richly mixed pleasures. He piles it on. His painting is luxuriously ornamental, curvaceously designed, sex-saturated, stuffed with money, filled with gold leaf and saccharine hues and suggestions of holy icons and sensory delirium. It is a supremely consumeristic art, where every kind of delight, high and low, carnal, spiritual, is fused. It is now the very epitome of Art Nouveau and fin-de-siecle Vienna. But it had to wait to become widely popular. It was only in the 1960s that these images with their smart graphics, their overt sexiness, their psychedelic glow, at last caught on.

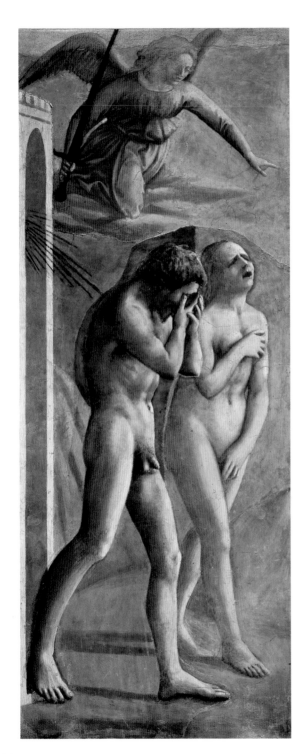

The Expulsion from Paradise
(detail) *c.*1425
Fresco, 206 x 88 cm
Brancacci Chapel, Santa
Maria del Carmine, Florence

MASACCIO

A&E! After the unfortunate accident, the terrible emergence. Adam and Eve, having eaten the forbidden fruit, are driven out of the door of Paradise. The angel with the fiery sword hovers above them. The voice of God, represented by blaring noise-lines, decrees their exit. Feet in step, the first two human beings enter a bleak desert, casting their shadows behind them as they walk towards the sun. They are completely naked.

Nakedness is an issue of course. The Bible says that, immediately after eating the fruit from the Tree of Knowledge, 'the eyes of both of them were opened, and they knew that they were naked, and they sewed fig-leaves together and made themselves aprons'. Physical self-consciousness is the first symptom of Adam and Eve's Fall from their original blessed state.

Most images of Adam and Eve apply this idea. Their genitals are hidden by some arrangement of leaves. Even pictures that show them before their Fall sometimes do this. Adam and Eve themselves may still be innocent, but we viewers aren't, and our decencies must be preserved.

Until the 1980s, the figures in Masaccio's *The Expulsion from Paradise* had a furl of leaves girding their loins. No surprise, perhaps. This is Adam and Eve after the Fall. But when the frescos in the Brancacci Chapel were cleaned and restored, along with layers of grime, this foliage disappeared too. The covering leaves were not part of the original work. They'd been added in the late seventeenth century. The artist's intention, it was now revealed, was to show the fallen pair quite naked.

Not that Masaccio's Adam and Eve are shameless. They cover themselves frantically with their hands. The way that they do this reflects a gender distinction. Eve's shame is bodily shame. She clamps her hands over her breasts and genitals, in the pose of the classical statue Venus Pudica. Adam's shame is moral or intellectual. He covers his face. Neither figure seems to be able to see where they're going. Adam's vision is blocked, Eve's eyes are screwed up and filled with tears. They walk blindly into their new life.

But there's also the question of what we can see – what their covering hands leave exposed. The critic Brian Sewell once acutely remarked that in a picture, 'the

penis is a deadly rival to the face'. He meant that both penis and face are objects of fascination, and that a painted nude can't show both without uncomfortably dividing the viewer's gaze. Masaccio's double nude shows the man's penis and the woman's face. Those are the two prominent body parts in the picture, and it is hard to say which upstages the other. Is it Eve's face, its mouth gaping formlessly in an animal howl of desolation? Or Adam's privates, which of all the elements in this picture seem to receive the most particular emphasis?

One can well understand why those seventeenth-century censors leafed them over. These genitals are conspicuous. They don't retreat into perfunctory unobtrusiveness. They're neither discreetly miniaturised nor vaguely generalised. They have a decent average size, they're decisively and realistically shaped – two clearly separate testicles; a distinct and pointy glans – all solidly picked out in light and shade. The penis doesn't seem entirely flaccid, either. There's a suggestion of stirring and hardening. And the way the genitals are set slightly forward from the body gives them a sense of independence.

The removal of the leaves really was a revelation. In no other Renaissance painting are adult male genitals singled out for such focus, given such a starring role. And since these are the genitals of Adam, Masaccio's emphasis may well have a doctrinal motive. Adam's penis was a matter of theological interest.

Before the Fall, St Augustine explained, Adam and Eve had full command of their bodies. They had sex, but even their sexual organs were 'aroused by will, at the appropriate time and in the necessary degree' rather than being 'excited by lust'. Adam's erections, in other words, were deliberate acts. And if we find that kind of bodily control hard to imagine, Augustine adds (in a slightly distracting digression), we should think of the way some people can waggle their ears, or twitch their scalps, or swallow and regurgitate small objects, or do bird imitations, or musical farting. That's the kind of total self-mastery humans originally enjoyed.

But after the Fall, Augustine said, sinful humans lost full control of their bodies. In particular, their private parts ceased to be obedient servants to their will. 'Because man did not obey God, he could not obey himself.' We humans

could no longer decide when to be aroused. Our genital organs now took on hideous lives of their own. (What Augustine says applies to both sexes, but he's clearly thinking mainly about the penis.)

Some modern thinkers have shared Augustine's sense that the uncontrollable erection constitutes a lamentable failure of self-command. Jean-Paul Sartre noted with compunction that the penis is not a 'fine, prehensile organ, rippling with muscles'. Its behaviour is 'biological and autonomous'. But others have found Augustine's idea of arousal at will an even more horrible thought: 'acrobatic prostitution', William Empson called it.

It would be difficult, maybe impossible, for any painting to indicate unequivocally whether a body movement was deliberate or involuntary. Is that gesture a reflex, or a decisive action? But if Masaccio is following Augustine, then the penis in this picture is a penis that has just acquired a life of its own. Its behaviour is no longer under the command of its owner. It is twitching into autonomous activity.

Certainly Adam's genitals are a centre of interest. And the way they half-rise and stand out makes this a plausible interpretation. In which case, Masaccio's *Expulsion* is one of the few European paintings to give proper attention to this vital fact of life.

Tommaso di Ser Giovanni di Mone (1401–28) had a brief and revolutionary career. Masaccio, he's better know as, a variation on Tommaso, meaning roughly Sloppy Tommy – that is, he was so devoted to art that he neglected his appearance. This Florentine artist is famous for introducing into painting both accurate anatomy and mathematically constructed perspective. His short life left few works. His masterpiece is the fresco cycle in the church of Santa Maria del Carmine where, said Vasari, all the later masters of the high Renaissance went to learn. They'll still let you in for a strictly timed twenty minute view.

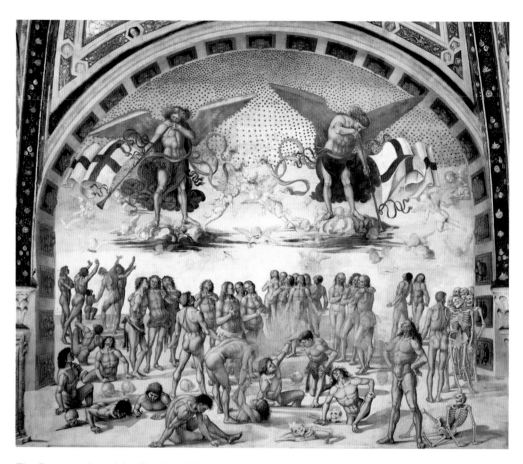

The Resurrection of the Flesh c.1500
Fresco, Orvieto Cathedral, Umbria

LUCA SIGNORELLI

It's one of St Paul's most spine-tingling passages. 'Behold, I tell you a mystery: we shall not all sleep, but we shall all be changed – in a moment, in the twinkling of an eye, at the last trumpet. For the trumpet will sound, and the dead will be raised incorruptible, and we shall be changed. For this corruptible must put on incorruption, and this mortal must put on immortality.'

And every Sunday, when Christians say their creeds – 'I believe in the resurrection of the body', 'I look for the resurrection of the dead' – they affirm this queer point of faith. When we die, we shall not say goodbye to our bodies forever. At the end of the world all of us, those dead and those still alive, will be clothed in an immortal body, which will be our own individual body, but renewed.

As theologians have explained, even in the afterlife there are no human souls without bodies: an immortal soul requires an immortal version of the flesh it once had. But since this new body must have no imperfections, it cannot be that of (say) a child or an old person. It must be a body in the full vigour of life. Some authorities specified that everyone would resurrect at the age of thirty-three.

The doctrine does honour the human body by insisting that we cannot, in any circumstances, exist without one. But when it comes to imagining this incorruptible flesh, theology describes something from which almost all the physicality is removed, which doesn't seem much like a body at all.

Resurrected bodies have four essential characteristics, technically defined as clarity, impassibility, agility and subtlety. They shine brightly. They cannot suffer or die. They can move as freely and as quickly as they like. They can pass through other objects. Altogether it sounds like a subject for the strange world of painting.

In the Capella Nova in the cathedral of Orvieto, Luca Signorelli made frescoes illustrating the end of the world. You can see the prophesied sights of the last days unfolding before your eyes – the great destruction, the reign of the antichrist, the rounding up of the damned, the crowning of the blessed. Every scene is thronged with figures. Half way through there's *The Resurrection of the Flesh*.

Two giant angels with long trumpets stand in the sky, blasting. Below them the earth is an off-white, flat and featureless stage, stretching away and stopping at an abrupt horizon in the middle distance. Its plain whiteness sets off the bronzed flesh and the shadows of the risen and rising humans, both male and female. They are joined by a smaller number of skeletons.

So some have emerged already in their new flesh, while the skeletons are waiting to put it on. A gang of boneys on the right are laughing at a body now in mid-metamorphosis, just acquiring its cladding of muscle. Mainly the figures stand around, exercising and enjoying their superbly strong new anatomies. They pull themselves up through the ground, and offer helping hands, and gather and embrace in a big reunion.

It's a very Renaissance scene: a display of magnificent physical specimens, not so different from one another, shown in a variety of poses and angles. It's like a cross between a gym and a *passeggiata*, and a modern viewer can't help getting a subliminal, anachronistic impression of the seaside.

But Signorelli doesn't show much interest in the supernatural side of his resurrected bodies. The enfleshing process is only briefly indicated. Their 'agility' and 'subtlety' are not apparent at all. (The blurriness in the middle of the picture is decay.)

The physical miracle is located elsewhere – not in the bodies, but in the ground. Traditionally, in resurrections, the dead rise from opened-up earth graves, or from stone tombs whose lids have flipped off. Signorelli imagines them directly rising through the surface of the earth, like worms.

The flat ground is another Renaissance feature. It's like the perfectly level stone floor of a piazza depicted in a perspective scene. But here it's cleared of buildings and made of an unimaginably ambiguous substance.

It's a kind of membrane, or quicksand, soft enough for a body to pass through it, and it hugs the penetrating limbs closely and closes behind them. But at every other point it's firm enough to stand on, and offer leverage. Painting's ability to depict the impossible comes fully into play.

Luca Signorelli (1441–1523) was a Renaissance virtuoso of the human body. He was taught by Piero della Francesca and later earned the admiration (and perhaps imitation) of Michelangelo. He did a lot of church painting, and some frescoes in the Sistine Chapel. His other great works are frescoes in Tuscany – the scenes from the life of St Benedict in the abbey of Monteoliveto at Chiusure; and above all the Last Judgement scenes in the black and white striped cathedral at Orvieto. Out-geniused by Raphael and Michelangelo, he returned to his birthplace Cortona, and became a rather boring provincial master. But in his vision of the Apocalypse, with flying devils attacking men on the ground with jets of fire, Signorelli seems to have fully anticipated the dive-bombing and rocket warfare of centuries later.

Study of Truncated Limbs 1818-19
Oil on canvas, 52 x 64 cm
Musée Fabre, Montpellier

THÉODORE GÉRICAULT

What's funny? In his philosophical study on laughter, *Le Rire*, Henri Bergson said that the definition of comedy was the triumph of dead matter over living spirit. A man falls over in the street. A person is a slave to their bodily needs. A character is fixed in a repetitive psychological pattern. These are basic comic situations. We laugh whenever human behaviour is rigid, compulsive, automatic. 'We laugh every time a person gives the impression of being a thing.'

In his book *The Act of Creation*, Arthur Koestler was having none of this. He retorted: 'If we laugh each time a person gives the impression of being a thing, there would be nothing more funny than a corpse.'

A good knockdown answer. But it's not quite the last word. For the fact is, *corpses are funny*. True, they may not be funny in life (so to speak), but they can certainly be very funny in art. They're good material for comedy. A cadaver on stage or screen is often a comic item. It's something that's got to be concealed. It must be lugged about with great difficulty. It has to be temporarily passed off as a living body. It won't stay properly dead, it keeps falling into lifelike postures and gestures.

Corpse-comedy is found in Joe Orton's play *Loot*, and the episode of *Fawlty Towers* where one of the guests dies, and the film *Weekend at Bernie's* ('Bernie may be dead, but he's still the life of the party!'). The basic joke goes two ways. Sometimes a corpse is like an extremely obstinate, uncooperative and insensitive person, who refuses to make any effort or response. And sometimes a corpse is like a weirdly animated object, a thing that can't help showing signs of life, involuntarily embracing or bashing or leaning affectionately on some other party.

A cadaver is like a person who gives the impression of being a thing – or, conversely, like a thing that gives the impression of being a person. At least, that's where the comic potential of corpses lies. It doesn't mean that a corpse is always comic. It only means that a corpse is an inherently troubling entity, an unstable hybrid of a person and a thing. Comedy is one way of bringing this trouble out, but not the only way.

Théodore Géricault's *Study of Truncated Limbs* is obviously not a comic

picture. You may well find it a troubling one. Its subject is simple: a tangled pile of severed human limbs, in a raking light. Géricault painted it when he was working on his most ambitious work, *The Raft of the Medusa*. This image of broken body parts, borrowed from a morgue, could be a detail from some massacre or disaster scene – except that there's no evidence of a wider catastrophe.

What you have here is a still life. It fits the traditional bill. It's an arranged display of inanimate objects on a tabletop. And that's where it gets troubling. A still life should have a lifeless subject, yes, but it should be a safe lifelessness, not the kind that makes you think of death. Vegetables are okay, and sometimes dead birds and rabbits; acceptable foods. Dead humans, especially chopped up, are not. Corpse still life? The subject is much too highly charged for still life's calm compositions. To make lopped human body parts into an artistic display is cruelly objectifying, dehumanising. What these things need is a decent atrocity.

Still, you might get away with it, if you played down their humanness. If you gave the limbs a medical presentation, as cool examples of anatomical dissection, it might not feel so cruel. That's just what Géricault doesn't do. He fills them with pseudo-animation. He arranges this pile of human hands and feet to suggest living body parts. It's a savage reminder – by contrast – of how dead and mangled they are.

It's like a love scene. The chunk of shoulder, arm and hand, with a bloody bandage still on the upper arm, lies in a languorous curl around the soft heel of the left foot. A fingertip just brushes a toe. It could be a close-up of post-coital bodies, lying head to foot in flopped tangle. The embracing darkness half disguises the dismemberment of the parts. The warm *chiaroscuro* adds dreaminess. You see sleepy limbs lolling in shadow, a nocturnal idyll. Then the wrenched wound at the shoulder breaks the dream. The drooping relaxation of these hands and feet has quite another cause.

Study of Truncated Limbs brings out the full troubling ambiguity of the corpse. It plays life against death, person against thing, loving gesture against

rigor mortis, caressing touch against ruined flesh and open wounds. The most gentle human situation, and the most brutal, are brought together. Sustaining it all there's a kind of pun, in the deceptive similarity between the sleep of satisfied desire and the inertia of death.

The image is like an over-literal realisation of the old equation of orgasm and dying. And the comparison goes further. By showing sex between dead body parts, Géricault evokes the way that any sex may involve fragmentation and objectification – in the attention that gets lavished on isolated bits of the body, in the pleasures of total passivity. In fact this isn't just a good painting of corpses. It's a good painting, simply, of sex.

One of very few. Western painting, for all the intensity it brings to the human body, hardly ever does sex. It does rape. It does violence. It does solitary nakedness. But two people having normal, mutual sex? Art leaves that to pornography. There is no proper sex painting. It's the most shameful omission. But Géricault, in an incredibly roundabout way, and tackling a far more shocking subject, gives a clue as to what such painting might be like.

Théodore Géricault (1791–1824) was a romantic fury – sick, driven, a self-confessed 'monster', perhaps insane, suicidal, though an infection killed him. His short and extraordinary career is overshadowed by a single picture, *The Raft of the Medusa,* a disaster epic filled with powerful dying bodies. He had a Michelangelesque devotion to the strong and suffering male physique, whether whole or dismembered – also to the bodies of horses, standing magnificently or wildly charging. There are two pictures entirely filled with rows of horses' bottoms. He made a series of mad portraits, of patients in a mental clinic (where he may have been a patient himself). They're neither pathologised nor romanticised: absolute human strangers.

Painter's Table 1973
Oil on canvas, 196.2 x 228.6 cm
National Gallery of Art, Washington

PHILIP GUSTON

Pinkstinks: that's the name and the slogan of a campaign, launched in 2009, opposing the dominance of pink in the lives of little girls. The campaigners observed that it's hard to buy girls clothes or toys that are not in some shade of rose, peach or fuchsia. And this uniform, they argued, offers girls the most self-undermining ideals: a girly, sugary, pretty-pretty, passive, flirty image, which prepares them for a life of hairdressing and lapdancing.

The voice of common sense retorted, of course, and what it said was that this colour was not being imposed. Little girls love pink. For a while they play at fairies and princesses. It's a phase. They go through it, and onwards, to become scientists and commandos. But both sides in this dispute seemed to agree on one point. Pink does mean something. It means girliness.

Colours do have values; it's good to have this acknowledged. They're rich in associations. They are symbolic. They carry feelings. But their stories are seldom straightforward. Pink, for instance, is the colour of the Breast Cancer awareness ribbon – pink, meaning female, and also evoking flesh.

The Pink Triangle is now the badge of Gay Pride. This is the inversion of its original usage, in Nazi concentration camps, where it was the badge worn by homosexuals – but also by sexual offenders. The Nazi colour choice was perhaps arbitrary. Perhaps again there was an implication of flesh.

That pink, at any rate, wasn't making an equation of gay and girlish. Pink wasn't assigned to girls until the mid-twentieth century. Nor is a powerful man today, who wears a bold pink shirt, considered girly. He's flamboyant. On the other hand, as Diana Vreeland said: 'Pink is the navy blue of India'; not flamboyant there at all.

In Christianity, deep blue is the colour of the Virgin Mary, while the Great Whore of Revelation is 'arrayed in purple and scarlet colour': both female, neither girly. But the pinks of contemporary little girlhood are, arguably, sexualizing. Like lipstick? It's a complicated area.

The great modern pink-painter is Philip Guston. In his earlier abstractions it's the dominant hue. In his later heavy figuration it becomes pressing. It's a rare colour agenda in painting. And if you thought pink must be sweet – even

Picasso's 'Pink Period', so dreamy and melancholic, comes up smelling of roses – think again.

Take Guston's still life, *Painter's Table*. It's not exactly a pretty sight, but semi-comic: nails, shoes, flat irons, books, stubbed butts, a canvas with a gaping eyeball, a palette, a smouldering dog-end, laid out individually. There are four main pinks: in the background; two on the tabletop; a very strong one on the canvas. Almost everything else is not pink.

Some Gustons are full of pink body parts, bulging, piggy flesh, with their outlines and shadows done in blood red. *Painter's Table* isn't literally meaty like that. But see how it's shaped and painted: saggy, lumpish, clumpy, sluggish, slobbish, squidgy.

This scene has a strong physical sensibility, in other words, and this gets into the pinks too. They may be, optically speaking, the same pinks you find in the girly wardrobe. But they don't feel like candyfloss or even lipstick. Colour never lives by itself. And in this setting, in this viscous brushwork, these pinks release quite different associations.

They become slobbish, squidgy pinks; if sweet at all, sickly sweet. Far from fairies and princesses, roses and fuchsias, these are the pinks of Germolene, sticking plaster, marshmallows, prawn cocktail, pork paté and sausage meat. Guston makes us face facts. Some pinks really do stink.

Philip Guston (1913–80) was a New York painter who changed course twice. He started figurative, with a blend of surrealism and social satire. After the war he went abstract, with a style sometimes called Abstract Impressionism, multi-coloured patches of paint densely huddling together in the middle of the canvas. But then, around 1970, cartoonish shapes began to coalesce, and what emerged was the most vigorous example of late-twentieth-century figurative painting – a vocabulary of gross body parts, eyeballs, hairy bollocks, fag-ends, hob-nail boots, dustbin lids, piled up, jammed together, painted raw, thick, clumpy, fatty, wrecked; hangover pictures, heart-attack pictures, a savage farce with solid presence, and a delicate wit articulating it.

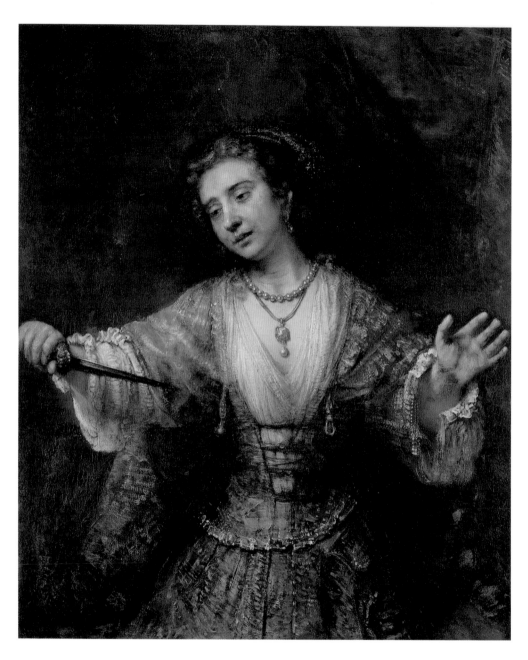

Lucretia 1664
Oil on canvas, 120 x 101 cm
National Gallery of Art, Washington

REMBRANDT VAN RIJN

A diagram, like a family tree, a flow chart, a Venn diagram, is a way of conveying information by making use of the space of a page. A diagram saves words, and can convey things that are hard to communicate clearly otherwise. Matters are laid out, and their relationships displayed, around a surface area.

The first step of a diagram is to visually itemise. The subject is broken down into key elements, marked by putting them in isolated areas, with some empty paper surrounding them, maybe with a ring or square drawn round them. The items are then arranged in sequences or groups or structures. Lines are used to indicate the relationships between them, lines that connect them up, or establish barriers between them.

As to where exactly on the page the individual items are placed, this may be a matter of indifference, mere convenience. But many diagrams make use of the basic spatial relations of a page – above and below, left and right, centre and periphery – to do some of their work. There are metaphors in these relationships that can be helpful.

Something at the centre is the heart of the matter. Something above is superior to something below (as in a diagram showing the structure of an organisation). Left and right are a natural way of arranging alternatives to be chosen between, the pros and cons of an issue.

Paintings too can work as diagrams – Last Judgements, for example. A traditional Last Judgement painting is not a realistic scene, a piece of futurological realism. It's not an attempt to visualise what the end of the world would look like. Its priorities are diagrammatic.

The standard format is to have Christ and his angels at the top, the earth and its inhabitants down below. Humanity is being parcelled up into the saved and the damned, the saved going off to paradise on one side, the damned consigned to hell on the other. A Last Judgement, in other words, is partly an 'organisation' diagram, showing the power structure of the universe, and partly a 'choice' diagram, showing the two alternative fates awaiting mankind.

But a Rembrandt? Surely not. He is the last artist who could be called a painter of schemes and diagrams. Rembrandt, painter of the flesh, painter of

the heart and soul, of love and mortality . . . But on the other hand, there is his *Lucretia*. It's a painting about a dilemma, it depicts a moment of decision, and it lays things out just like a good diagram would.

The story: an honour self-killing. A noble Roman wife is raped by her noble house guest. Her husband returns the next day. She tells the story, and stabs herself in front of him. In the picture Lucretia stands centre, facing picture front. It puts her in direct contact with the viewer, killing herself right in front of us. It gives this narrative subject an aspect of portraiture, or even self-portraiture. But also, the way the body is posed and lit and framed maps it squarely and diagrammatically onto the space of the picture.

The lighting concentrates on Lucretia's key parts. The head, the hands, the breast, are the bright elements. These parts are separated and set out in the most demonstrative way. The head is put top centre, above and between the two hands. Those hands are placed on a level with each other, at the very opposite sides of the picture. The right hand holds out the suicide-knife. The left hand is raised, open and empty. Exactly between them, at the heart of the picture, lies Lucretia's heart, the knife's target.

On the one hand – on the other hand. To be – or not to be. That's how the picture is structured. The figure's pose embodies its fateful predicament. It's like an allegory of its own choice. Here is the moment of suspense, between death and life, and the opposing hands, the opposing options, are held before us, symmetrically balanced, with maximum distance between them. The hand that says die, and the hand that says no. The viewer's own gaze can turn between one and the other. But the choice isn't yours, it is hers, and you see that her choice is made. Her head has already turned.

At any rate, that is what the *structure* of the picture says – a diagrammatic layout designed to display the heroine's dilemma and her decision. But the structure is not the whole picture. There is also the body that inhabits this structure, that's caught in this fix. How does the body respond?

Another body in another picture might have obeyed its framework with firm and definite gestures of its own. It might have given us a spectacle of

rigid, determined, unflinching, inexorable Roman heroism. Or again it might have looked trapped in its predicament, stretched out, straining, pinned down, crucified on its dilemma-diagram.

Rembrandt's *Lucretia* does neither. Her body may find itself diagrammed, but it responds to this fix with the least definite behaviour imaginable. There's neither conformity nor struggle. Nothing stiff, nothing staccato, nothing dramatic or heroic or agonised. Rather, the head leans to the side with a look of inexpressible mildness. The failing gesture of the raised left hand is beyond interpretation.

This is an image of someone whose life has moved outside human reach and understanding. She doesn't act out a moment of decision or crisis. The action of the figure has a slow drift, a slow sideways sway to it. Imagine the right hand held no knife, and was held up empty like the left hand is. It wouldn't be a suicide picture. It would be a picture of someone dancing – alone, gently, dreamily, with herself. Lucretia, or the Last Waltz.

Rembrandt Harmenszoon van Rijn (1606–69) stands as more or less the Shakespeare of painting – the non-classical artist who gives you the full human range, the full human depths. Like Shakespeare, Rembrandt didn't begin to get European recognition until the start of the nineteenth century. Unlike Shakespeare (to the endless frustration of literary people) Rembrandt left a large quantity of self-portraits, which depict a life trajectory from early confidence, brilliance and success to later sorrow, struggle and profound self-scrutiny. It's these images above all that give the artist the status of secular saint, a prophet of the religion of humanity. But what Rembrandt can put into a face, a pair of eyes, is certainly equalled by what he can put into a hand, into a touch. The word is mercy.

The Apparition of Ten Thousand Martyrs c.1512
Oil on canvas, 123 x 177.5 cm
Gallerie dell' Accademia, Venice

VITTORE CARPACCIO

Yan, tan, tethera, methera, pip; sethera, lethera, hovera, dovera, dick: so begins one of the traditional counting routines used for tallying sheep in the north of England. The sheep pass one by one through the gate of the sheep-fold, and the shepherd keeps up this numbering chant, which hits a strong beat every five digits – pip (5), dick (10), bumfit (15), jiggit (20) – so that rhythm and arithmetic keep pace.

But you can count sheep in another way. The proverbial visualisation technique, used for getting oneself off to sleep, is not concerned with arithmetic. It involves a different kind of numbering and a different kind of beat. As the imaginary ovines pass before the mind's eye, you're counting not 'one, two, three', but 'one, one, one'. You're keeping up a steady and repetitive rhythm, focussed on this succession of identical units, coming at regular intervals, going on indefinitely. You're after a hypnotic monotony.

The Christian legend of the Ten Thousand Martyrs is a story with a number attached to it. It's an unfeasibly large number, of course, the kind of number that - unlike the three bears or the seven dwarves – just registers as a great multitude. What can you do with Ten Thousand Martyrs? March them up to the top of the hill?

Not far off, in fact. The Ten Thousand Martyrs were supposed to be an entire Roman Legion who, during the reign of the Emperor Diocletian, had unanimously converted to Christianity. Ordered to worship pagan gods, they refused – and were marched up to the top of Mount Ararat and crucified en masse.

Vittore Carpaccio painted an altarpiece image of this execution extravaganza. *The Ten Thousand Martyrs of Mount Ararat* is densely packed with naked tortured figures. The scene piles up and stretches away into the distance. You almost believe that, if you tried, you'd be able to count ten thousand individual martyrs. But as part of the same commission, Carpaccio painted another picture, of a more recent and more local incident.

In 1511, Francesco Ottobon, a prior of the Venetian monastery of St Antonio di Castello, had a dream. In this dream he saw himself at prayer in the monastery church (he was praying that the monks be spared the current outbreak of

plague). Suddenly there was a great noise outside. The church doors opened. A multitude of men, carrying crosses, began to walk up the aisle in procession. At the main altar they knelt, and were blessed by a figure Ottobon identified as St Peter. They passed through, 'two by two, resounding sweetly in hymns and songs'. Ottobon recognised the stream of pilgrims in his dream as the ten thousand martyrs of Mount Ararat. A few years later, Carpaccio pictured this dream in *The Apparition of the Ten Thousand Martyrs*.

Most of the scene is the church itself. It's a working church filled with accumulated, untidy detail. You notice the images on the facing wall, traditional gold-framed icons and – above the side altar – a work of contemporary Venetian painting, an atmospheric landscape, school of Bellini. You notice the abundance of dangling ex-votos, thanksgiving offerings, effigies of bones and body parts and model ships, signifying the donors' delivery from accident, disease or shipwreck. The wonder takes place in a realistic setting.

The space of the church is like a box. Its big airy volume is symmetrically arranged, and viewed, from floor to rafters, in four-square perspective. It's set straight on to the picture's view, as if the picture's frame was the rim of this open box. It's like a high proscenium arch stage, and it has two entrances, one on either side. Through this lucid space, across the bottom, coming in right, going out left, threads the double file of robed walkers.

Carpaccio animates the procession, putting the advancing figures in a sequence of poses that break down their actions in a stage by stage way – gradually sinking to their knees as they approach the altar, rising again, passing either side of it, moving on. But these individual poses don't interrupt the flow of the line. Everything stresses its steady, continuous progress. The procession is straight, and runs exactly parallel to the picture, and the figures are spaced out at pretty regular intervals. This is a line that keeps coming, that goes on and on.

Unlike in his mass crucifixion scene, Carpaccio doesn't try to persuade us that we have thousands of men crammed into our view. There are only about twenty-five figures crossing this stage – with a few more glimpsed through

the open right-hand doorway, part of the waiting queue in the ante-chapel. It is enough. The picture suggests enormous multitudes by implication. We have a line of men crossing our field of view, but it's a line of which we can see neither the beginning nor the end. We see only the brief section of it that is now appearing between entrance and exit. What's off-stage might be infinite. The queue could go on filing past forever.

The dreamer himself is the little man in white, kneeling at the railing on the left. He turns round to catch, over his shoulder, the extraordinary sight. As sometimes happens, the dreamer himself figures in his own dream. But what makes the scene most dreamlike is the parade of pilgrim-martyrs. This continuous and potentially endless stream of individual figures passes through with a hypnotic, repetitive, sheep-counting effect. It creates a sense of transfixed, ongoing, timeless flow. *The Apparition of Ten Thousand Martyrs* is a trance-state image.

Vittore Carpaccio (1450–1525) is one of the great painters of the human scene. The same Venetian generation as Bellini and Giorgione, he was less concerned with visual atmospherics. In his scenes every detail is clipped and clear and superbly arranged. His dramas occur in single rooms, among fantasy architecture and realistic street views, in formal processions and killing fields. His greatest works remain in Venice. The *St Ursula Cycle* is in the Accademia Gallery. The *Scenes from the Lives of St George and St Jerome* are still in the little chamber of the Scuola di San Giorgio degli Schiavone.

1024 Colours 1973 (CR 350-1)
Enamel on canvas, 254 x 478 cm
Centre Pompidou, Paris

GERHARD RICHTER

One should never underestimate the power of meaninglessness. Late-twentieth-century art certainly didn't. The painted void, the wholly meaningless, utterly indifferent picture, became a quest. One common solution was extremely minimal: the 'monochrome', the single coloured canvas. Another, still more powerful, was a bit more maximal. It involved a multitude of colours.

Gerhard Richter's *1024 Colours* is a great wall of indifference. It consists of a regular grid of 1,024 coloured oblong units, divided by a network of white lines. It's 32 units high by 32 units wide. Each oblong is a double square, and the picture itself is approximately a double square.

Formally, it's an overtly overwhelming painting. It's very big, for one thing, almost five metres across, with a panoramic format that fills your field of vision. With its layout of repeated flat units, it faces you unremittingly. Its multiplicity is excessive: the number of its distinct bits appears as a sheer ungraspable proliferation. And its all-over grid makes it a completely full canvas, evenly occupied from top to bottom, side to side, without any slackening of visual pressure. But what exactly is there to see?

Put out some preliminary probes. Perhaps there's an image in there? For centuries Western picture-viewers have learnt how to deal with a chaotic looking, bits-and-pieces painting: stand well back, blur your vision, and wait for something to materialise. But *1024 Colours* yields nothing of that sort. These panels aren't pixels that resolve into a picture, or into any other kind of abstract shape or decorative pattern.

So what about the colours themselves, do they have a sense? The painting obviously resembles a commercial colour chart, or a child's watercolour box. But equally obviously its colours are not grouped together in that way. They lie scattered and mixed up apparently at random. Nor is there any bias in the choice of colours that would establish a particular colour scheme. At a glance it seems that all the colours in all their variations are present.

What you suspect is in fact the case. The colours have not been selected. They are a 'complete' set, 1,024 different colours, devised according to a programme, and covering the full range of hue, strength and brightness. Each unit is a different

colour. The large number of near-blacks are simply the darkest shades.

There is no arrangement either. The colours are distributed across the grid entirely at random. There are of course gazillions of possible permutations. (1,024 x 1,023 x 1,022 x . . . x 3 x 2 x 1 is the formula for how many.) Richter painted *1024 Colours* in four different random versions. This one in Paris is the third version.

1024 Colours, in other words, is a painting all made up of colours where the choice and disposition of colours are matters of total indifference. Human design has no role in it. It might as well have been composed by a machine. It might as well have been painted by one too. It's executed in enamel gloss, the least flexible of paints. The paint is put on uniformly, with no trace of handiwork.

The network of white lines prevents one unit of colour from touching, chiming and blending with another. Even the possibility of chance harmonies occurring among the random colours is eliminated. Colour, famous for being the most passionate element of the art of painting, is reduced to a sequence of separate neutral samples.

1024 Colours seems designed to be mute and blank, a grand negation of painting and its traditional satisfactions. Surely, whatever interest we try to take in it, it will not respond or resonate. But strangely this isn't so. Its very indifference becomes a kind of perfection and a kind of force. Its defiant negatives turn out to be almost indistinguishable from painting's traditional qualities.

Random distribution, for instance, is an excellent way of making a balanced composition. A chance scattering of a compendium of colours across a regular grid will generate automatically the kind of equilibrium that hand and eye would struggle to achieve. At the same time the completeness of the palette, with every colour represented, gives a sense of great abundance, while the unpredictability of arrangement prevents this from becoming a mere glut, produces an impression of inexhaustible variety.

There is a constant dialogue between parts and whole. Presented with a variegated surface, your eye naturally seeks patterns in it, sub-divisions, some kind of internal order. With *1024 Colours* it can have a transient success, as it latches on to (say) the undulations and knots made by some of the lighter units.

The field of multi-coloured bits is endlessly generative of these configurations.

But these patterns can never be fixed on securely. Your eye is always likely to be thrown outwards towards the picture as a whole with its firmly sustaining structure of rows and columns. Alternatively your eye falls inwards, upon the individual oblongs of colour, which may be picked out, one by one, each one transmitting its singular identity.

So this wholly indifferent composition performs like a great classical masterpiece. It achieves, without trying at all, the classical virtues of balance, plenitude, variety, unity-in-multiplicity, inexhaustible richness. Though constructed on the model of a colour chart, it comes to feel like a real painting.

In fact, it's a much stronger work than any actual classical masterpiece. Next to it, every hand crafted, eye-designed painting is going to look vulnerable, flawed, wonky. It will be making gestures, having ideas, trying to do things that almost certainly won't quite come off.

1024 Colours has no purposes that can fail, no impulse within it than might disturb its performance. It works by itself. Its magnificence is 100 per cent reliable, 100 per cent risk-free. In fact, it's more like an exposing parody of those classical virtues (balance, abundance, unity etc.), demonstrating how they can be delivered, in very pure form, with no struggle, just by applying a programme and throwing a dice.

Gerhard Richter (born 1932) hasn't stopped painting. Though suffering a total loss of belief in his art, he's kept going. He's been compared to the Christian theologian who said, 'I believe because it is absurd.' East German born, trained in Socialist Realism, he came West and practised a form of Pop Art he called Capitalist Realism. He tries to detach painting from all its traditional values: observational truth, expressive handiwork, creativity. He is a technical wizard, with a genius for self-effacement – and so his work acquires the mystery and authority of something that has appeared from nowhere.

The Ruins of the Old Kreuzkirche in Dresden 1765
Oil on canvas, 84.5 x 107.3 cm
Kunsthaus, Zürich

BERNARDO BELLOTTO

How does art make mess? The composer Harrison Birtwistle once compared his methods with those of the painter Francis Bacon. If painters want to introduce some chaos or disorder into their work, they can simply, physically, mess things about. They can (like Bacon) fling a handful of paint at the canvas, or attack the surface with a sponge or rag or broom, or even get someone else to do it for them. But with composers, Birtwistle said, it's different. If they want to put disorder into their music, they have to write out every note of it. They can't just make a mess. They have to make it up.

Not every composer would concur. There are other ways of producing musical disorder. You can determine the sequence of notes through rolls of a dice. You can flick ink onto sheet music or (like John Cage) project a map of the night sky onto the empty staves – and make each spatter, each star, into a note. The music is generated from random or non-orderly schemata.

Alternatively, you can tell the performer to mess it up for you. The first movement of Carl Nielsen's *Fifth Symphony* comes to a violently conflicted climax. At one point the snare drum, whose part has previously been written out in full, is instructed to improvise 'as if at all costs to stop the progress of the orchestra'. The drummer must find ways to jam and disrupt the structure of the music played by the other instruments.

A tricky business. In any deliberate attempt to make mess, whether composed in the studio, or improvised in performance, there's the risk it won't be really messy. The would-be mess-maker is liable to fall back into some kind of order, to revert to those pattern-making habits which – for cultural and perhaps biological reasons – are the default mode of the human mind.

People sometimes talk as if the great achievement of art was to impose order on the disorder of experience. Of course there are many different sorts of order, some more interesting or astonishing than others. But order as such is no great shakes. The real struggle is to avoid it – as anyone knows, who tried as a child to draw a map of an imaginary island, and found that the ins and outs of the coastline kept turning into an unnaturally regular decorative border. The ability to purposely create or imitate irregularity is a form of

virtuosity, a mastery against the grain of our inclinations.

Paintings of ruined buildings have many points and pleasures. They can revel in destruction. They can present a melancholy vision of transience and doom. They can demonstrate survival and endurance – because something still stands in spite of being ruined. They can show the gentle return of the man-made to the organic world, as natural decay and overgrowth reclaim a human construct. They can also present a drama of the regular and the irregular. That's the dominant theme of *The Ruins of the Old Kreuzkirche in Dresden* by Bernardo Bellotto.

The Church of the Holy Cross, the oldest in Dresden, had a catastrophe-prone history. In 1760 it suffered another setback, being shelled by besieging Prussian artillery. The body of the church caught fire and collapsed. The tower survived. But five years later, with reconstruction work in progress, it too mostly fell down.

This is Bellotto's subject, painted on the spot. The shell of the church tower rises out of a heap of its own rubble. The wreckage is fresh. There's been no time for the softening influence of weather and vegetation. The fractures are still sharp, declaring the recent shattering violence. The picture contrasts the standing up and the fallen down, the hard-edged vertical and the spreading amorphous mass. The new ruin is like a nude with its clothes at its feet, or a skeleton stripped of its flesh, or a body eviscerated, the prolapsed innards spilling out before it.

And everywhere disorder disrupts order. It's a spectacle of various kinds of chaos. There is the general tumbledown shape of the tower, as against its still imaginable upright form. There are the jaggedy and spiky details of its fracturing, as against the geometry of the surviving arches and perpendiculars. There's the pile of rubble itself, a more or less regular pyramid, but made up of a random scatter of fragmented masonry and timber and dust. Flanking the disaster area there's a bank of new public buildings, emphatically straight-lined. But away in the distance on the left another irregularity appears, in the skyline silhouette of the older, poorer houses. It looks almost as random and ruined as the tower's stark, broken-toothed profile.

Some of Bellotto's contemporaries had begun to experiment with direct mess-making. Alexander Cozens in his *New Method of Drawing Original Compositions of Landscape* showed how to develop landscapes out of rapidly splashed down blots of ink. Cozens pursued a natural look through random processes. But Bellotto's mess-making is not like that. He is the composer who must write out every note. This painted simulation of a credible chaos – the meandering zigzags of the broken edges, the higgledy-piggledy distribution of fallen pieces – is all his own work.

He had the sight before him, true. But that wouldn't teach him how to paint it. He had to want to get the messiness right, and he proceeded perhaps by trial and error, perhaps with the use of some controlled explosions: giving a judder to his brush, or quickly dashing and dotting his strokes. The marvel of the scene is not only in the way it preserves a violent catastrophe. It's in the fact that this ruinous mess is all formed by human hand and human judgement – in other words, by an instrument deeply resistant to the production of disorder.

Bernardo Bellotto (1720–80) was a Venetian topographical artist who did a lot of work in Germany and Poland. He was one of the great painters of brickwork. He was the nephew and pupil of the artist normally known as Canaletto (whose real name was Antonio Canal), but Bellotto also called himself Canaletto, and this can still cause confusion. Perhaps it was a professional ploy. He doesn't need one now. Recent taste has moved decisively in his favour. Canaletto's sharp sunlit views of Venice, twinkling with spots of bright colour, have been upstaged by Bellotto's more sombre northern townscapes, with their moody lights and silver-grey-green-browns.

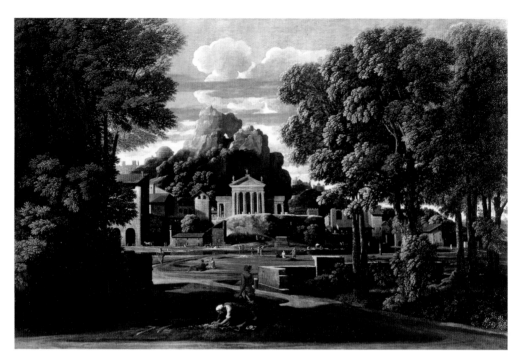

Landscape with the Ashes of Phocion 1648
Oil on canvas, 116.5 x 178.5 cm
Walker Art Gallery, National Museums Liverpool

NICOLAS POUSSIN

The city plays many roles. It is hell. It is a fairground. It is a madhouse. It is a celestial palace. It is a great machine. That's the role it's given in Walter Ruttmann's 1927 silent film, *Berlin: Symphony of a Great City*. Though the metaphor is supposedly musical, the visual effect is more mechanical. A day in the life of the city is translated, not into a symphonic structure, but into a series of routines and reiterations.

Doors opening; vehicles moving; crowds passing; humans walking, working, eating, dancing; wheels turning; gadgets shuttling: all these behaviours, living or not, are repetitive, and in their repetition they all become equal and one, a single driving incessant operation. Even when individuals briefly emerge, the effect is only to stress the pattern. Through sheer accumulation, automatism becomes a kind of aggrandisement. We're enlarged by the whole into which we're all incorporated.

Or take another city vision, this time a still image. Nicolas Poussin's *Landscape with the Ashes of Phocion*, though it's called a landscape, is obviously a townscape. It's an imaginary view, created by an artist living in seventeenth-century Rome, of an ancient Greek city-state. This city is Megara, and the ashes . . . but the story can wait. Most of the painting's story is in Poussin's construction of a civilisation. And Poussin is famous for his order.

A picture makes order with spatial devices: symmetry, centring, verticals, horizontals, parallels. Poussin's city uses them vigorously. A row of massive oaks, heavy with foliage, runs right across the foreground. It's a high natural city wall planted alongside the actual low wall, a great shady barricade. But it has an opening. These guardian trees frame the city like a pair of curtains or wings. A road runs between them, coming from outside. Bracketed by the dark trees, the luminous city appears beyond, a composition of arches, pillars, squares, rectangles, diagonals – buildings that suggest a set of toy bricks.

But it's clear at once that Poussin's order is unlike Ruttman's. *Berlin* has a uniform repetitiveness. It's a process with no climax. Megara has a structure. It's ruled by a centre and a hierarchy. The façade of the classical temple looks straight out at us, pretty well from the middle. It is the face of the city, the focal

point of the whole scene. But this temple isn't the culmination. Standing behind it, much higher, there's a great wooded rock, its two jagged molar stumps emerging from the vegetation covering its base.

The city was founded here, presumably, because of this wild and sacred natural formation. And the rock is not simply the city's heart. It is the peak of a pyramidal form that rises up gradually on each side from the ground, and which shelters the town and seems to touch the sky. Above it there's a third element, a solid and graceful crown of cloud. Temple, rock, cloud: they stand like a mysterious symbol, the vertical alignment that sustains the civilisation.

Having noticed this organisation, though, notice also that it's complicated. It's wrong to overstress it. The scene has clear regularities, so it is tempting – for the sake of drama – to call it strictly regimented. You can say the temple is dead centre, the city rises as a symmetrical pyramid, the wings of trees hold it in a symmetrical frame, the temple-rock-cloud stands like a vertical column.

But not quite. While the picture is on the verge of these geometries, it carefully avoids them. Its potential centring, symmetry, verticals, are shifted a step to the left. The design of Poussin's Megara may be more hierarchic that Ruttmann's Berlin. It's much less rigid too.

Within this structure, the life of the city freely flourishes. If you let your eye move among the specks of humanity that inhabit the flat ground and the heights, you pick up constant activity: walking, talking, reading, music, shooting at a target, swimming . . . and there's always another, smaller speck to notice. It's meant to be a little hard to take in. That is the measure of its freedom.

It's not a world where every inhabitant is being arranged into a visible pattern. Its life is going on regardless, going on without *you*. You, as you look at this picture, are an outsider, remote from the bright city and its happy pursuits, beyond the wall, in the deep shadow of the oaks.

In other words, it's a picture about exile. And this is where the story comes in. Phocion, an Athenian general, was falsely condemned and executed, and his unburied corpse banished, and taken to the outskirts of Megara, where it was burnt. At the very front his faithful widow gathers his ashes. Her servant

keeps lookout. The outcasts are directly below the mighty nucleus of temple-rock-cloud.

But nothing in the scene indicates that the civilisation from which they're excluded is itself evil or oppressive, that they're well out of it. No, their exile from the good life is sheer tragedy. This city is a symphony, and it continues behind them undiminished.

Nicolas Poussin (1594–1665) is known as the most cerebral of painters. When the sculptor Bernini looked at his work, he remarked: 'Mr Poussin is a painter who works from up here,' tapping his forehead. Poussin, born in France, operated mostly from Rome. His painted 'high' subjects – from the Bible, classical legend, ancient history, epic poetry. He constructed his scenes using model theatres, paying great attention to their visual and symbolic plotting. These were images for private study, for an intellectual elite, not public works for church or state. But their patient deliberation can accumulate into a massive force, and they're capable of articulating the most violent emotions. A mouth in a Poussin painting was a crucial inspiration to Francis Bacon's screams. His work was much collected in Britain, and is well represented in the National Galleries of London and Edinburgh.

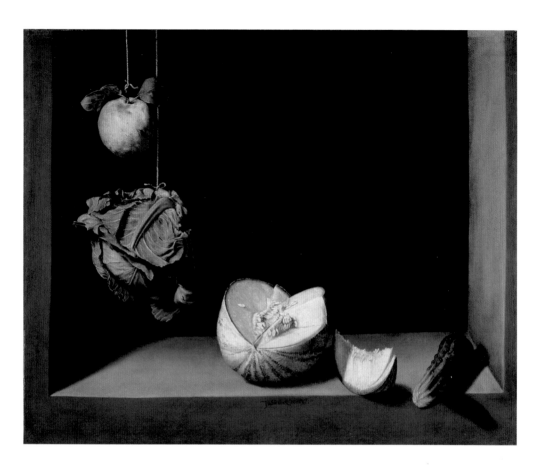

Still Life with Quince, Cabbage, Melon and Cucumber c.1600
Oil on canvas, 69 x 84.5 cm
San Diego Museum of Art

JUAN SÁNCHEZ-COTÁN

There's a theatre story told about Tallulah Bankhead, and no doubt it's told about other performers too, because these tales get distributed. It goes like this. A rival actress is bragging that Bankhead is not so talented – she can upstage her at any time. To which Bankhead replies 'Darling, I can upstage you without even being on stage!'

And at the next performance, Bankhead gets to work. Making her exit at the end of their scene together, she pointedly sets down a glass of champagne (with some adhesive on its base) over the very edge of a table. There it remains for the rest of the act, impossibly balanced, stealing all eyes.

But an impossible balance may not be necessary to get our attention. Accidents can always happen, and we have a keen eye for potential disaster. As Pascal said: 'If you put the world's greatest philosopher on a plank wider than he needs, but with a precipice beneath, however strongly his reason may convince him of his safety, his imagination will prevail.'

Precariousness: something so nearly is, so easily could be, otherwise, you can't help imagining a turnaround. It happens in pictures too. In fact, the Bankhead stage trick might have been learnt from painting. There's a favourite device of still life artists who want to put suspense into the inanimate. A plate, a basket, a knife, is projected out over the edge of a table, so that its centre of gravity lies just short of that edge. A jog might send it over. In the stillness of the scene, there's a fall impending.

That's simply achieved. Things in pictures are not under real gravity. But just a hint of jeopardy will usually do. Many still life pictures employ this effect and generally they want only a faint frisson of instability. They don't want to upstage the whole scene with a single object that lies in fascinatingly miraculous equilibrium. Then again, there are some still lives where almost everything – one way or another – is on tenterhooks.

Juan Sánchez-Cotán's *Still Life with Quince, Cabbage, Melon and Cucumber* is one of the pinnacles of the art. In this scene, fruit and veg are translated into pure form. Within an oblong stone frame, five ingredients are displayed: a quince, a cabbage, a cut melon, a slice of melon, a cucumber. Each object

is picked out separately against the darkness or the smooth stone. Each is modelled firmly in the cool, sharp raking light. They are like geometric solids. Each one is exactly placed.

They are arranged in a regular descending curve – a hyperbola, to be precise. This is achieved partly through the relative sizes of the things, and partly by suspending two of them on strings. Down they come, one by one, step by shallowing step. And at the end of the curve there's another bit of geometric punctuation. The diagonal shadow of the cucumber cuts off the surface of the sill so as to leave a neat isosceles triangle.

It is a supremely graceful layout, but more than that, it is a dramatic one. The drama is in the tension between the curve and the objects that compose it. The curve holds its objects, imposes an order on them. On the other hand, the objects are in principle moveable. They could well lose their exact positions in the sequence. They put the perfect curve under a pressure of precariousness. All five objects are still, but only one is stable. The central dissected melon sits safely grounded on the stone ledge, safely back from the brink. With the other four, their stability and stasis are at risk.

You notice how the curve does not simply descend within the window frame. It goes slightly aslant the frame's edge. It curves out, towards the front of the picture, across the lip of the sill. It brings the melon wedge and the cucumber forward, and they perform the standard still life suspense trick. They project out over the edge.

They are probably not too far gone. But they look as if they might - with only a little nudge, a little shove – tip over. How easily the melon wedge might rock on its hard curved skin. How easily the cucumber might cantilever. There's only a margin of sill between where they sit and a sheer drop. The shadows they cast beneath them foreshadow their possible fall.

Now go to the top end of the curve, to the two dangling objects. Their positions are even more dicey. Look especially at the marvellous cabbage, hanging heavily in mid-air on its long fine string. It is certainly in a precarious state. It's not that it might drop. There's no reason to think the string will break.

The thing that might be broken is the cabbage's stillness.

We understand it to be perfectly motionless, but how vulnerable that stillness must be. It is about the same size as the melon that sits just below it, but its physical situation is conspicuously different. It hangs there, utterly exposed and unsupported. And as with any highly fragile but stationary situation, its stillness acquires a kind of aura. It's like a house of cards. The slightest touch or draught, the least unwinding in the string's fibres, might make the cabbage sway, and lose its place. It is the weakest link in the hyperbola.

So there is a play to and fro between the unnaturally perfect curve and the naturally precarious objects that make it up. You can look at the scene and see an exquisite, almost transcendent order that embraces the everyday world. Or you can see a display of contingency, a very deliberate and fragile construction. One firmly settled object is flanked by things whose positions are finely calculated and perilous. At any moment they could slip, tremble, swing, succumb to gravity or change and destroy the pattern entirely. Both Tallulah Bankhead and the greatest philosopher might be impressed.

Juan Sánchez-Cotán (1560-1627) was one of the earliest pure still lifers in European art, and one of the most piercing. The fame of this Spanish painter rests on a small number of pictures, all using the same format, a stone window frame, within which highly realistic items of food sit or dangle – game birds, tiny apples, the mighty cardoon. It is a minimal art of few ingredients, in which form and colour can be tightly controlled. In mid-life, Cotán chose a religious vocation, becoming a lay-brother in the Carthusian order, and it is tempting to see his still lives as sacramental, or at least frugal. His explicitly religious paintings, however, have not proved nearly so popular.

Swift Hope 1927
Oil on canvas, 49.5 x 64 cm
Kunsthalle, Hamburg

RENÉ MAGRITTE

You know the scene. An old soldier is replaying a favourite battle on the breakfast table. 'We were *here*,' he says and puts the sugar bowl in the northeast corner, 'Jerry was *here*,' and the marmalade is recruited, 'the Yanks were *here*,' a china plate, 'the village was over here,' a cereal box is laid flat, 'and the river' – a moment's hesitation, and then spoons and forks are arranged into a trailing line of silver – 'the river was here. Our objective lay . . .' etc.

And you know how this scene (when it appears in a work of fiction) usually ends. The old buffer becomes excited and muddled. He forgets what stands for what. The fighting impulse takes over. Other utensils that haven't been allotted any part in the scheme get drawn in. A general battle of the breakfast things prevails. 'The toast-rack must be eliminated!'

It's a story about representing. In order to re-enact his battle, the man improvises a very rudimentary, and therefore fragile, form of representation. One thing stands in for another very different thing. There isn't any likeness between the two things, nor any established link, apart from the old soldier's say-so. Consequently his scheme can easily break down into confusion. It's only a first step towards image-making.

But there is *some* likeness. A pot of marmalade may not look much like a unit of German troops, but in several ways the tabletop does resemble the battlefield. The relative sizes of the stand-in objects are roughly right. So are their basic shapes – the village is a compact form, the river is long and thin. And the spatial relationships between them are certainly meant to be accurate. Perhaps it's a bit more than a first step.

You can imagine the level of likeness being raised – or reduced. The stand-in objects could be made to correspond more and more closely, to more and more aspects of the things they stand for. Alternatively every element of the battle, even the river, could be represented by an identical teacup. That would be a very minimal scheme. It would carry just two kinds of information. It would show the number of distinct items that were involved, and it would show their layout on the ground.

Magritte's *Swift Hope* makes a similar reduction. It offers a very inarticulate

image, just about the minimum that will qualify as a pictured scene. And to emphasise the point, Magritte labels the image with some paradoxically specific words. But ignore the white labels for the moment. Concentrate on the deep blue scene. How inarticulate is it really?

It's not a complete mess. It shows five clear elements, five rounded forms, with distinct shapes and different sizes. They have a hint of solid volume, a lighter patch swelling out of the middle of each one. You can't say precisely what they are, but they're not just anything. They're definitely something blobby – like megaliths, or inner organs, or amoebae.

You can say more. The long thin one is standing upright. Three are lying on the ground at various distances. The small one is off the ground. In other words, the scene doesn't only consist of these five blobs. It situates them within a view and a three-dimensional space. *Swift Hope* has the same spatial structure that you find in many pictures. It divides into two parts. Below, there's a ground level; above, there's a backdrop.

It is the standard picture stage-set, a template that's used in various types of scene. In a landscape, it corresponds to the surface of the earth, stretching to a horizon, with the sky beyond. In an interior, it is the floor of the room, meeting the back wall. In a still life, it is the table or shelf, and the wall behind it. The content changes, but the structure remains, and within it objects can be located as near or far, on the ground or in the air.

And Magritte's apparently elementary image holds another kind of information: shadows. Each of the five blobs has an area of darkness behind it that registers as a shadow cast on the adjacent surface. These bits of shadow aren't put down very precisely or consistently. There are isolated dark areas that aren't near to any object. But the effect is enough to stick the blobs to the ground they sit on, to make them seem more solid, to create a sense of dim lightfall.

Even without the labels, you'd probably have an idea that this scene was a landscape. And when you read them, what they declare isn't in fact so paradoxical. *Tree, straight road, horse, village on the horizon, cloud*: the words

correspond pretty well to the shapes and sizes and positions of the five blobs. The tree is a tall thing. The horse-form almost has a head. The village is indeed on the horizon.

True, it's weird to have a road represented by a long solid object, but it points away into the distance as a road might well do. And the cloud is funny, being such an abrupt lump, and apparently casting a shadow on the sky, but it's where a cloud should be. There isn't a sharp disjunction between the things and what they're meant to stand for – rather less sharp, actually, than in the breakfast battle scene.

Swift Hope is like a world in embryo. It feels thwarted and straining, a nocturnal, pupal landscape where things have not yet emerged into their destined identities. It's like Alexander Pope's lines about 'the Chaos dark and deep, / Where nameless somethings in their causes sleep'. But Magritte's somethings are not quite the forms of things unknown. You can see how these blobs could fulfil their waiting names. They just need licking into shape. By contrast, the title of the picture is utterly baffling.

René Magritte (1898–1967) is naturally a paradox. The Belgian Surrealist, popular and influential, he's the straight man who painted bizarre scenes in a deadpan manner. But he makes sense. He couldn't paint very well, but his work is a sustained exploration of the language of images. With a vocabulary of brick walls, clouds, apples, nudes, eyes, rocks, bowler hats and handwriting, he's always making a point about how pictures work and how strange pictures are. He plays with scale, perspective, shadow, illusion. He revels in metamorphosis, in the weightlessness of the pictured world, the way you can never know what's behind something. With Magritte, a picture becomes a place where everything is trapped and anything is possible.

Alexander's Victory (*Battle of Issus*) 1529
Oil on panel, 158.4 x 120.3 cm
Alte Pinakothek, Munich

ALBRECHT ALTDORFER

In *The Face of Battle*, John Keegan pointed out that traditional military historians often show an unrealistic grasp of battle experience. They say things like this: 'The French reserve, mixing with the struggling multitude, endeavoured to restore the fight, but only augmented the irremediable disorder, and the mighty mass, giving way like a loosened cliff, went headlong down the steep . . .'

Keegan calls this kind of writing the Battle Piece. Abstract forces contend. Fully coordinated bodies of men, all apparently behaving as one man, impact on one another. Fighting is a matter of these masses advancing, colliding, shaking, penetrating, overwhelming, mixing, scattering, processes that are almost dreamlike in their lack of substantiated causation.

The Battle Piece has its main eye on outcomes: who wins, who loses. It uses, Keegan observes, the abstract terms in which a commander – not the fighting man – might visualise things: 'Large, intellectually manageable blocks of human beings going here or there and doing so, or failing to do so, as he directs. The soldier is vouchsafed no such well-ordered and clear cut vision. Battle, for him, takes place in a wildly unstable physical and emotional environment . . . it will centre on the issue of personal survival, to which the commander's win/lose system of values may be irrelevant or directly hostile.'

Most battle paintings turn out to be a kind of the Battle Piece. Or you could say that the Battle Piece is already a pictorial version of events. It views a battle as a composition, albeit a mobile one, a matter of shapes and their interplay. It arranges and organises things as a painter might do. It shows the big canvas, the overview, the grand design, the strategic picture, with a symphonic sense of events ineluctably unfolding.

Conversely, some critics have considered battles as excellent material for a picture. As static images, pictures cannot easily represent a rapidly changing sequence of events. But some kinds of activity they manage well. According to James Harris, eighteenth-century art theorist, amongst 'the fittest subjects for painting' are 'such actions whose incidents are all along similar, such as a battle; which from beginning to end presents nothing else than blood, smoke,

and disorder. Now such events may well be imitated all at once; for however long they last, they are but repetitions of the same.'

Harris doesn't sound much like someone who's been in a battle. 'From beginning to end . . . nothing else than blood, smoke, and disorder . . . however long they last, they are but repetitions of the same . . .' He imagines a battle as a continuous roaring uniform melee, a kind of Andy Capp dust-up or Western bar-brawl on an epic and lethal scale, everyone fighting everyone for hours without a break. It's an even more abstract Battle Piece than the old military historian's version. It takes a very long distance view, at any rate. And what would such a picture look like? Like Albrecht Altdorfer's *Alexander's Victory*?

It is history. The battle in question is the Battle of Issus, fought in 333BC, in which Alexander the Great defeated Darius III of Persia, near what is now Iskenderum, in Turkey. It was predominantly a cavalry battle, with about 20,000 mounted troops on each side. Darius had chosen a battlefield between mountain and sea that left him not enough room. The day was filled with multiple changes of manoeuvre. General rout followed.

Altdorfer does the scene modern and Alpine, not ancient and Asian. These are fifteenth-century armoured cavalry. But updating doesn't mean realism. The whole fight is presented as a mass jousting pageant, but much too packed for jousting, an tournament of impossible density, in which it is hard to see how any lancing actually gets done.

The picture has its eye on other things – on a sense of enormous numbers, for example. Picking out every single fighting man in the foreground, it makes you feel that this individuation continues even into the blurred crowds of the far distance; each brigade is packed close with infinite ant-like men.

And it is not Harris's constant rolling chaos of 'blood, smoke, and disorder'. It has a sense of manoeuvres, of this engagement and that engagement, of different parts of the battle, troops close-fighting, wheeling, charging. These episodes are not meant to be simultaneous, even though their precise sequence isn't obvious.

The picture has sense of the whole battle, the whole day. Space signifies time.

The massive vista gives you a comprehensive vision of all its events together which – though not meant as simultaneous – can't help looking as if they were. It's an all-day sky, too. It stretches between moon and sun.

The sky takes up the battle. The arrayed and turbulent cloud formations are forces fighting it out. The heavens join in. It makes the battle look legendary, of world historical or cosmic significance, a last battle, a battle for civilisation or the fate of the universe.

The perspective gets more and more historical. And when you get to the great placard hanging over it all, high in the sky, with its flying banners and dangling tassel, you have risen centuries above the fray. You are looking back down on it with the transcending eye of posterity, and the involvement you might have felt when paying attention to its details is now a distant memory, all a long time ago.

The placard's Latin inscription is a tally: it records the enormous numbers of dead on either side. The conflict is fought under the serene sign of history, the outcome known and announced, even as it rages. By Keegan's standards this is far from an accurate portrait of battle. But no other picture gives such a breathtaking sense of the pathos of historical distance – the historian's 'survivor guilt', of looking back, fascinated but uninvolved, on the furious irrecoverable battles of the past.

Albrecht Altdorfer (c.1480–1538) is famous for kind of inventing landscape. *St George in the Forest* is – a small St George apart – nothing but vegetation. He was a leading artist of the so-called Danube School (which also includes Cranach). He mostly made religious images. He painted *Alexander's Victory* for the Duke of Bavaria's gallery of classical battles. He was not the first to depict it. One of the most complex images to survive from classical antiquity is the Alexander Mosaic, first century BC, discovered in Pompeii, now in the National Archaeological Museum in Naples. It was not known to Altdorfer, because Pompeii wasn't excavated until the eighteenth century.

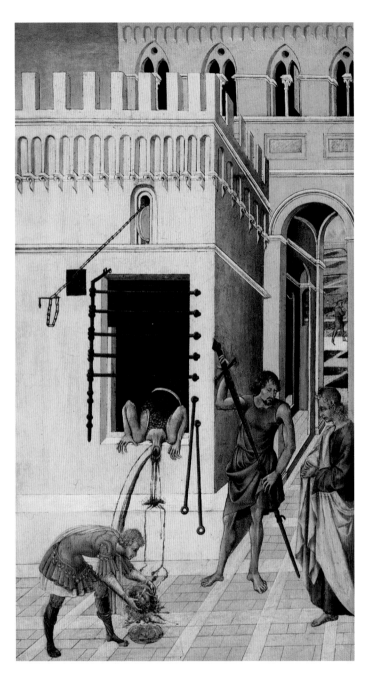

The Beheading of St John the Baptist 1455–60
Tempera on panel, 68.6 x 39.1 cm
Art Institute of Chicago

GIOVANNI DI PAOLO

Films today come with censors' advice, declaring what they contain in terms of language, sex, nudity and violence, often registering fine gradations. Contains moderate language and one scene of moderate sexualised nudity. Contains strong language, sex references and brief bloody violence. Contains frequent moderate action violence. Contains strong language, sex references and nudity. Contains very strong language and strong bloody violence. Contains very strong bloody violence, medical gore and sustained terrorisation etc.

There is no censorship of paintings. If there were, what would it say? The old masters, when they occasionally added words, used the most decorous language, taken from the scriptures or the classics. When it comes to sex and nudity, there is plenty in post-Renaissance images – though how sexualised the nudity, how strong the sex is, can be uncertain. As for violence, in art from all ages it is frequently extreme. Paintings contain very strong bloody violence. In spite of our high expectations of high art, we can hardly fail to notice this – and even have qualms.

In fact our objections to violence in art are resourceful. We worry in opposite ways. Sometimes it seems that the treatment of violence is too sensational, gruesome, relishing. Sometimes it seems too beautifying, formal, composed. This is a subtlety the film censors overlook. They never say: contains brief aestheticised violence. But both attitudes have something heartless about them. One approach plays the violence up and the other plays it down. Both offer a wrong, though different, kind of enjoyment. And given that violence shouldn't be wholly excluded from art, but shouldn't be too enjoyable either, it seems hard to get its treatment right.

There are some pictures that at least achieve a mixture: gore and aesthetics crossed. Giovanni di Paolo's *The Beheading of St John the Baptist* is one. This small episodic panel comes from a sequence about the harbinger-saint, who went into the wilderness and announced the coming of Christ. Later he was imprisoned by King Herod for criticism. Then Salome danced for the King, with strong sex references, and demanded his separated head as her prize.

It's a scene of shocking realism, psychological and anatomical. The King,

a meekly monstrous figure, creeps in to supervise the executioner, who is just concluding his calm work. Meanwhile before us there is the revolting accuracy of the beheading. St John's torso appears through the prison bars, with its bunched arms, its stretched and severed neck, suggesting a cook's chicken, plucked, trussed, decapitated.

His cut neck sends out a double issue of blood. One stream spills downward from the wound in dribbles. The other is an arcing jet of arterial blood spurting outwards. These details were presumably public knowledge. Both the artist and his audience had seen this kind of thing happening in the piazza, in penal actions.

Around the human mess, the whole scene is beautifully clean and straight. Red spatters on white. The sticky gouts of blood play against the smooth planes and sharp corners of the prison architecture. The arches and castellations, the tiled paving and the oblique chequerboard countryside glimpsed through the gateway: all this neatness stresses, by contrast, the bloodletting. A soldier picks up the Saint's dripping head from the ground. Its halo lies beneath it like a golden plate.

But there is also pattern in the violence. The trajectory of St John's arcing blood is paralleled by the slant of the diagonal chain coming out from the pulley in the wall above it at 45 degrees. The end of this curve of blood is picked up by the soldier's cloak as it hangs at a vertical from *his* neck.

The other stream of the Saint's blood, pouring down, descends in a straight drool onto the stone ledge below, pools there, forks into two, trickles in double parallel lines onto the pavement, then forks again – and there's a likeness between these forkings and the hanging bars of the jail's grille. The carnage falls into these elegant arrangements, but they can also make it crueller: human blood is compared to harsh metalwork. Some patterns beautify. Some exacerbate.

There is bloodshed and geometry. Di Paolo makes them both like and unlike, and the effect is both to aggravate and to compose the horror, in ways that can't be disentangled. Quite proper, perhaps, given what the subject is. This

isn't any killing. It's a martyrdom, so the meaning of its violence is inherently ambivalent. On the part of the perpetrators, it's an outrageous crime. On the part of the sufferer, it's to be sanctified and welcomed. This makes art's business easier. From a radiant transfiguration to a ghoulish horror: almost any point on the scale of response will do.

In *The Beheading of St John the Baptist* the balance probably favours degradation. The spouting chicken-victim isn't much redeemed by the formal patterns. But the general case of martyrdom suggests another refinement of the censor's classifications. Contains very strong bloody glorifying violence.

Giovanni di Paolo (roughly 1399–1482) was a Sienese painter about whose long life little is known. His fame resurfaced in the twentieth century. A good deal of his work is known. There is his *St John the Baptist Goes into the Wilderness* to be seen in the National Gallery in London. He painted radiant heavens and crisscross landscapes. He illustrated Dante. He practised the wiry, old-fashioned manner of the International Gothic, with a fantastic imagination. He is compared with de Chirico. One modern art historian says: 'Few experiences in Italian painting are more exciting than to follow Giovanni di Paolo as he plunges, like Alice, through the looking glass.'

Holly Leaf on Red Background 1928
Oil on canvas, 92 x 65 cm
Private collection

FERNAND LÉGER

The holly bears the crown, as the old carol sings. It bears a blossom as white as lily flower. It bears a berry as red as any blood. It bears a prickle as sharp as any thorn. It bears a bark, as bitter as any gall. And the carol goes on to explain that these various aspects of the holly each stand for an aspect of sweet Jesus Christ's life and mission.

For Christians, and before them for Celts and Romans, holly has been a sacred and symbolic tree, especially associated with the festive season – Saturnalia, Christmas. That Christmas carol shows just how meaningful the plant can be, or can be made. It positively sprouts with allegories. On the other hand, turn to Fernand Léger's *Holly Leaf on Red Background*.

Léger's realisation of the holly goes quite the opposite way. It is secular. It is literal. If at Christmas time holly becomes a richly articulate plant – for the godless too it is a cheering, evergreen sign of life in winter – Léger's holly is strictly dumb. You might say that in his picture it becomes a purely natural thing, but even that would be an exaggeration.

This holly leaf might have been part of a festive still life, it might have been part of a thriving woodland scene. It's neither. This single leaf is extracted from all surroundings or roots. It lacks any suggestion of life context or life source. It lies isolated on a plain background. It's not a growing organism. It's presented like a cut-out botanical specimen.

The emphasis in this image is on the holly's substance - on its conspicuously unvegetable substance. Holly is anyway far from being a succulent plant. Its surface is sharp and shiny. It is easy enough to see it as being made of plastic. Léger takes this further. He brings out holly's hard, metallic quality.

You see this in its edges and its spikes. They look like a piece of sheet metal that's been cut into curves, and bent and twisted. These edges are themselves cutting edges. These spikes could pierce flesh. It's a stuff that makes you think of a can and a can opener. The holly's evergreen flesh is given the permanence of metal. (Its spikiness is upped by the two spikes that are on the point of touching the top and bottom edges of the picture.)

You see it in the leaf's colour too – or rather in its de-colouration. The holly's

green is turned into black and white. This has a biological implication. Drained of green is drained of chlorophyll. The leaf is specifically dead. Admittedly, the deep red background has a counter optical effect. Through complementary contrast, this red introduces a hint of green into the monochrome leaf. But it's only a mild hint.

The main effect is to say the opposite: that unlike the background the leaf is utterly without hue. The background is filled uniformly with the most primary of primaries, a saturated red. The leaf has only tone and form. Our attention is all on its light and shade and shaping.

And the leaf's shaping is especially stressed because it is so peculiar – extremely complex and perhaps impossible. This holly leaf is made out of curves and spikes and waves just like a normal holly leaf. But the way these forms are assembled is another matter.

For example, try to follow its formations, its bumps and hollows, as indicated by the shadings and highlights across its surface. It's like an area of corrugated iron, dented and folded. Now compare this convolution with the shaping implied by the outside edge on the left side. Can the two be coordinated?

And then try to visualise the forms that are suggested by the edges on the right side, as they zigzag in and out, as their spikes fold in and out. It is nearly impossible to translate this holly image into a real curling form in three-dimensional space. It only exists as an image.

The punchline, the grace note, is that small tusk that emerges from behind the leaf, top right. How, where could it be attached to the leaf? Nowhere. Yet in terms of pure design it couldn't be more strongly attached; it picks up neatly onto a curve that passes 'through' the leaf and into a spike that appears the other side.

There is no religious symbolism, here. There is no nature sentiment. There is simply physical presence. The holly leaf provides Léger with an object for variation, for pattern, for intensification. (His first move was to strip off its berries.) He intensifies it by making it dangerously sharp. He intensifies it by making it spatially baffling. He intensifies it with a surround of blazing red. The holly bears the crown.

Fernand Léger (1881–1955) is the most embracing of modern painters. He continually refuses to be alienated or agonised. He pursued an open, public, monumental and democratic art that would manifest the new forms and promises of twentieth-century industrial life. He was at first an outrider to Cubism; his version, with its stress on cylinders, is sometimes called Tubism. After fighting in the First World War, and apparently immune to nightmare visions, whether of war or industry, he evolved a vocabulary of half-abstract machine shapes and semi-robotic humans. His 1924 film *Ballet Mécanique* was a great celebration of repetitive forms and repetitive rhythms, a manifesto of new impersonal beauty. Later, Léger developed a more humanist repertoire of heavy but buoyant figures, working and playing together, with a famous sequence of builders on girders – safe, graceful, optimistic, but tough, and never simply jolly.

Right and Left 1909
Oil on canvas, 71.8x 122.9 cm
National Gallery of Art, Washington

WINSLOW HOMER

Bang, bang. Snap, snap. The analogy between the camera and the gun, the photographer and the gunman, is long established. Both load. Both take aim at their target. Both shoot. And the act of taking a picture has often been equated with an abrupt act of violence. It is Susan Sontag's opening gambit in her famous essay, *On Photography*. It is the theme of several films: Antonioni's *Blow Up*, Michael Powell's *Peeping Tom*.

What prompts the thought is not only the likeness of their mechanism – the protruding cylinder, the sights, the finger pressure, the sudden click. It is the moral likeness. Gun and camera are examples of 'action at a distance', and put a distance between the shooter and the world. Gunman and photographer hunt their quarry. Gun and camera, in an instant, stop things dead.

The art of painting, by contrast, is hardly ever compared to firearms. When people think about painting and violence, they come up with different analogies, more suited to the medium and the process. Painting is a hands-on activity. Painting is not instantaneous. So when painting is seen as violent, it's not a matter of shooting, but of slashing and punching and forcing. The brush and the shaping hand become the knife and the fist, and the liquid paint squashes like flesh or runs like blood. From Caravaggio to de Kooning, artists themselves have likened the act of painting to a physical assault.

Still, paintings have much in common with photos. They frame their subjects. They freeze their subjects. They are concerned with viewpoint and distance. They don't snap, but they often depict instants. What's more, after the invention of photography, paintings often have photography in mind, and invite the viewer to notice both the differences and the similarities. So if a photography-gun analogy is natural and obvious, a painting-gun analogy is certainly possible too.

Bang. Bang. Winslow Homer's *Right and Left* is a painting of a shot, two shots. But what fills the frame are the targets – the convulsed bodies of a pair of goldeneye ducks as the pellets hit them in mid-air. The 'right' and 'left' of the title refer not to the ducks, or the order in which they are hit, but to the double barrels of a shotgun. The sportsman's knack is to fire them off in quick succession, right and left, bagging two fowl on the wing.

Among all the paintings that linger over the bodies of dead game birds, arranging them gorgeously and pathetically as still life objects, this painting is unique in confronting, directly, immediately, the moment of death. And in a number of ways, it makes connections between the act of picturing and the act of shooting.

It is a close-up. It brings you right up to an event that would normally be seen from afar. The picture's point of view is startlingly nearer than a gunman's sight would be. You feel the viewpoint has jumped, like a jump-cut in cinema. It makes you conscious of the distance between the gun and the birds, and the way a shot fired instantly crosses this distance.

There is a switch of perspective. You may presume, at first glance, that the birds are at least seen from the aiming gunman's angle – until you notice that the gunman himself is in the scene, almost concealed behind the left-hand bird's tail, a little figure in a boat cresting a wave on the choppy water. And he's firing. There's a puff of smoke. So this is literally a bird's-eye view. We have a bird's glimpse of its fellow birds, and of the man killing them. We are in his line of fire.

It is a freeze. This painting, like any image, has its inherent stasis. Here that's equated with the sudden stopping of these two birds, shot in their tracks as they fly across from right to left. And they're in perfect focus too. To the eye, shot birds would be a chaotic blur, but these are shown with clear-edged forms, suggesting a snapshot, a photographic instant. The image, like the shooting, is a split-second affair. And there's that sudden white splash in the water, too, like the discharge of a gun – perhaps even cast up by a spray of shot.

It is a two-part image. The two birds, side by side, left and right, with their sharp and contrasting configurations, represent the two shots. Each shape is a flinch, a moment of flung impact, a bang. One bird's head points horizontally left. The other's points straight down. The second bird is like the first bird, rotated through 90 degrees. The wings flap, the wings fail. Perhaps the left-hand bird has just missed death. They are like Fig. 1 and Fig. 2, a live bird and a dead bird. The picture holds this two-stage, flip-book action. At the same time, it's an instant. The shots are successive but virtually simultaneous.

In these ways, *Right and Left* makes a link between being pictured and being shot. It makes you think about distance, aim, rapid fire, instantaneous impact. Yet its most surprising effect is its formality. It depicts something that is very quick and violent. But look at the bodies of the ducks: they're set in the picture like the heads in a double portrait. They are in the throes of wounds and death, but the way they're framed and laid out, they suggest trophies in a glass case, almost the proverbial flyers up the wall. And the very coolness of this presentation, the detached beauty of its design, feels like violence itself.

Winslow Homer (1836–1910) was, in his time, the 'great American artist'. It might be truer to call him the great American illustrator. Illustration had been his first career. He went to Paris and saw Impressionism, but didn't really take it to heart. He came back to work in Maine, and developed a heroic and sometimes mythic realism, evoking the force and wildness of the sea, and human battles with it. His famous pictures, like *The Life Line* and *The Undertow*, have big power, but generally lose little of it in reproduction. It's all in their monumental shapes, and half-hidden narrative clues.

The Dog 1820–23
Oil on plaster remounted on canvas, 134 x 80 cm
Prado, Madrid

FRANCISCO DE GOYA

It's a frightful picture of dream-like helplessness and despair. It's also a demonstration of the power of simplicity. Goya's *The Dog* is one of his so-called 'Black Paintings', the sequence of murals, usually with nightmarish subjects, that the artist painted on the walls of the Quinta del Sordo, a country house outside Madrid he occupied in the early 1820s.

These murals were eventually detached, and ended up in the Prado Museum. The house itself was demolished. And the state of the 'Black Paintings' remains doubtful. How much of Goya's handiwork and intentions survive, after suffering years of decay, and the shock of being dismantled, and successive restorations by other hands?

These doubts do not diminish their force and mystery. Among them all, *The Dog* is an image of the very worst. Its paint surface is also clearly in a bad way. But that only seems to exacerbate the poor animal's misfortunes.

The picture's structure is minimal and non-specific. It is divided in two, an above and a below. The upper area is a pale golden yellow; the lower one is brown. The upper area fills most of the picture; the lower is a strip across the bottom with a slanting wavy edge. You could call the upper area sky, and the lower one earth.

You may also see another vague form in the upper area, of a slightly darker yellow, looming above the dog on the right side: it shows up more in some reproductions than others. It may possibly be part of the scene. It may be part of a previous painting that this scene was painted over. Whatever, discount it – simply because the picture is better if you discount it. There are enough uncertainties already.

Where are we? Who knows. Because the scene is so minimal and non-specific, it is highly ambiguous. What is the spatial relationship between earth and sky? You can see the earth as a foreground, a mound or ridge, with the sky beyond and behind it. Equally, you can see the earth as if in cross-section, a layer, with the sky simply above it.

But earth and sky are too definite names. The sky might be a sheer face of rock, or some kind of vapour or torrent. The earth need not be solid ground. It

might be in convulsion. It might be made of a soft or fluid substance. Its wavy edge might be some kind of wave. And altogether, there is no sense of scale or orientation in this world. We are simply in the midst of it.

There are, however, two crucial pictorial facts that determine our experience of it. First, there is the shape of the whole picture, an exceptionally tall, narrow, upright oblong – indeed perversely tall, narrow and upright, considering that the scene is, after all, a kind of landscape. Secondly, there is the ratio of the areas within it: the upper area very deep, the lower area very shallow.

These extreme proportions have an inherent drama. Whatever finds itself in the lower area is right down at the bottom of the vertiginous scene, as if it was at the bottom of a well or a cliff. And there is a great void or a great mass of something above it. It? Time to bring in the dog.

If not for the dog, we would hardly see a landscape in these forms at all. But of course we only see the head of the dog, poking into the upper area, its body in some way obscured by the lower one. It raises a snout hopefully. It has a most pathetic, anxious look in its eye. It gazes up, in the direction of the rising wavy edge. And the uncertainties and proportions of the scene all fall upon it.

You can see the creature as submerged in the lower area, up to its neck in it, buried in the ground, or swallowed up by something more liquid, like quicksand. It is stuck there, sinking, unable to extricate itself. It raises its head, trying to keep itself 'above water'. But the great empty gulf that towers above it only emphasises its helplessness. Not only stuck in the ground, but with nothing anywhere in reach that offers rescue, a foothold, leverage.

Alternatively, you can see the dog as cowering behind a ridge, trying to hide and protect itself. It raises its head in trepidation, looking up at the impending danger from above – which might be some kind of landfall, flood, storm, or torrent of volcanic ash. And now the depth of the upper area signifies the overwhelming volume of whatever this threat is.

Either way, it is a picture about bare survival in the face of hopeless doom. Whether the danger comes from below or from above, the picture tells us there is no escape. There is no way out of the drowning mire. There is no hiding place

from the avalanche. This is the effect of its very elementary structure. The scene consists of *nothing but* an above and a below. Each is a source of dread, and the little dog is caught between them.

That's why the picture is better if you discount the vague looming form (which may or may not be part of it). This form would offer the dog some shelter from the above, some possible rescue from the below. Or again, if it seemed a menacing form, it would only be a partial, local source of danger, a distraction from the total, immersing world of danger of the above or the below. It would mitigate the dog's loneliness before its fate.

And the fact that we see only the dog's head, and nothing of its body and limbs, further reduces its chances of escape. It is deprived of any sense of movement or action. It is only a head, a consciousness, lost in a universe of terrors, afraid for its life.

Francisco de Goya (1746–1828) has something for everyone. If he'd died in his forties, he'd be remembered as a talented court painter. But the mysterious illness that befell him wasn't fatal. It left him stone deaf and a genius. In his images of witchcraft, bull fights, carnival, nightmare spooks, the terrors of war, the Inquisition, sexual delight and sexual corruption, he became a master of fantasy and documentary. His appeal is now uniquely broad. Almost every artist alive today, from the crustiest to the most cutting-edge, will have a good word for Goya.

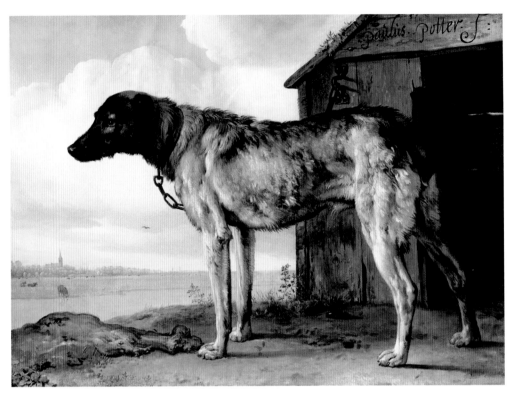

The Wolfhound 1650
Oil on canvas, 96.5 x 132 cm
Hermitage Museum, St Petersburg

PAULUS POTTER

Educational illustrations of contraceptive devices used to include a 50 pence piece, lying amongst the caps, coils and condoms, 'for scale'. This naturally encouraged jokes about the coin's own prophylactic uses. But a 50 pence piece wasn't a bad choice as a scale marker. The seven-sided coin is a familiar object, of fixed dimensions, and unlike circular coins it only comes in one size. There's no mistaking how big it's meant to be.

Scale in paintings is a more complicated and often more elusive matter. There are issues of distance and issues of viewpoint to be factored in. We assume that familiar objects are of normal dimensions. We try to make things fit together. But sometimes the artists don't want the relative sizes of things to be decisively fixed. They want to let in a bit of free play and possibility.

Paulus Potter's *The Wolfhound* is one of the great dog portraits. Like other dog portraits it shows an ambivalent attitude. It admires the dog both for its domestication and for its independence. The dog occupies the frame, commands the scene. No humans are in view to master or upstage it. It is a surrogate human itself. It stands in a presentation pose, in formal profile, in front of its (man-made and artist-signed) house.

But unlike a human portrait, the 'sitter' here is chained into its position – the dark links of the chain discreetly but clearly indicated. This bred, trained animal is still a wild beast, who must be restrained, and the picture suggests that it lives by itself, on the edge of the land, away from human habitation, supplied with chunks of raw meat (one lies at its feet). It is on watch, looking out of the picture. It is probably a guard dog.

It may also be a monster. Not only are there no bigger humans in view, there is nothing in the picture to establish a definite scale. The solitary hound stands outside its kennel, but such wooden structures come in all sizes. The kennel could be as big as a barn. There's the piece of meat at its feet, but the size of a cut can vary too. This one might be half a cow. Even the bits of sprouting ground-vegetation can be seen as tall nettles and cow parsley, not small shrubs.

So turn to the background scene. Again, no clear scale is established. We

can see the far bank of a river, a cow drinking, a wood, a settlement with a church, and all these things may be assumed to be normal sized. But how near or how far are they? What we can't see is how the ridge on which the dog stands relates to the river beyond, or how wide that river is.

There is no continuous terrain from foreground to background, just a jump. Their distance and their relative scale become unjudgeable. Old films use this jump-trick when they want a little model castle, set in front of a real landscape, to look big and real too. The dog benefits from a similar 'special effect'. For all we can tell, it could be as big as a horse, a house.

Crucially, the viewpoint is low. The horizon lies at the level of the hound's leg joints. We're looking up at it. And if we imagine that in this picture, as in many pictures, the viewpoint corresponds to the eye-level of a human standing on the ground, then the dog would be a colossus.

True, it is all a matter of what can be imagined. Literally, the artist hasn't forced or falsified the evidence at all. This could be a realistic image of a normal wolfhound standing in a normal world. It's just that the scene fails to provide any reliable scale markers, and then – with its low viewpoint – it offers a hint as to the creature's gigantic stature. But it's only a hint. This dog could still be normal, and simply viewed somewhat from below.

Metaphorically, on the other hand, the message is clear. This viewpoint makes the dog tower over the horizon, the church steeple, the bird in flight. We're to feel that it keeps guard and keeps watch over this domain. Its head is high in the sky. Its nose is keenly in the air.

And see how the fur of the head suddenly darkens, directly against the bright white of the clouds. It makes the hound's profile as sharp as a cut-out silhouette. It becomes the point of maximum tonal contrast in the picture. The sharpness stresses the watchdog's poise, alertness, sensitivity. The darkness gives it an edge of menace.

Paulus Potter (1625–54) was a specialist, as were many artists of seventeenth-century Holland. Some did landscapes, some still lives. Potter painted animals, mainly farm animals. In his short life (he died of tuberculosis) he became the most accomplished *animalier* of his age. A close observer of animal behaviour, he established cows, horses and dogs as subjects deserving of individual depiction, their forms often silhouetted against an open sky. In the nineteenth century his life-sized image of a *Young Bull*, which looks a bit twee now, was considered one of the star exhibits of Dutch art, along with Rembrandt's *Night Watch*.

Place du Théâtre Française 1898
Oil on canvas, 73 x 92 cm
Los Angeles County Museum of Art

CAMILLE PISSARRO

As they'll tell you in any creative writing class, point of view is crucial. Take that old favourite, the everyday object seen from an unusual angle. It's the staple of puzzle pages and amateur photography clubs, but it has a finer artistic pedigree too. The Surrealists were drawn to the way an oblique view can estrange normal experience. The Renaissance painters who first discovered perspective weren't averse either, showing off their new skills by depicting things in extreme foreshortening, so that the eye is momentarily disoriented by a human figure that's, say, lying on the ground and viewed directly end on, feet first.

The overhead view is just a more comprehensive version of this trick. A tract of ground is seen from above, and the world is made strange. Some things are unrecognisable. When viewed from overhead, human bodies and actions lose their shape and their sense. People are compacted into blobs, and their behaviour becomes meaningless. From this angle, you can't pick up the usual signs of purpose and effort. You can't see arms and legs and faces. You can't even tell the difference between the body's front and back. You get an absurdist vision of humans milling about like micro-organisms on a specimen slide.

But other things become strangely explicit. From overhead, the layout of the world is clearly mapped out – likewise, the positions, formations and directions of its population. It is a demographic view, showing you how people gather together and the tracks they take. It's the view of the social scientist, the town planner, the statistician.

The overhead view generates a purer, more abstract image. There is no horizon. The standard division of a scene into ground and sky is abolished. There is no depth. Everything is more or less the same distance away, on a level surface. There is no gravity, no up and down. What you have is a uniform, flat and weightless field, holding a pattern of shapes and spots.

In the 1890s Camille Pissarro, Impressionist and Anarchist, was painting Paris from a number of high windows. His focus was downwards – down on to the squares and streets, on to the crowds and parades and pedestrians and vehicles. *Place du Théâtre Française,* from 1898, is his most downward view, the picture that's most full of road and road-users and little else.

A couple of historical points. The painting dates from the dawn of the age of the automobile. There might have been the odd car on the streets of Paris. But all Pissarro's vehicles, the carts, buses, cabs and carriages, are horse-drawn. It also dates from the height of the Dreyfus affair, and Pissarro was a passionate Dreyfusard. But no sign of political disturbance or demonstration occurs in this or the other street scenes. All attention is on the everyday urban world passing beneath the window one morning early in the year.

It is not, of course, an overhead view. It may make you think of an overhead view, because it's obviously a long way off from being a street level view. And if you're interested in searching the art of the past for premonitions of modern art, then *Place du Théâtre Française* certainly offers a hint of abstraction. You can imagine the left-hand side of picture – where there are no buildings and bus stops, which consists almost entirely of street and traffic – tilted up further, so that it becomes a pure configuration of dots on a plain ground. You might feel that the picture actually encourages you to imagine that alteration, by the way that it keeps all the vehicles and pedestrians as isolated shapes, just as they'd appear if they *were* seen from directly above. But still, they are not.

No, this is a halfway view. The angle to the ground is about 45 degrees. Neither ground level, nor aerial, it is a perspective that has its own particular sense. Unlike a ground level view, it can display the paths and communal patterns of human behaviour. Unlike an overhead view, it doesn't make human behaviour look absurd or mechanical. Each of these figures and vehicles has visible life and intentions. There's a good deal of observation and characterisation, of hurry and waiting, of the way the different classes go to work.

You might call this kind of view an 'activity view'. It's designed to show a whole field of activity in operation, a world interacting. Pissarro portrays the complex self-regulating behaviour of traffic, the complex reciprocations involved in crossing the road. No other angle could do these things properly. The 'activity view' is designed for depicting social life. It can present collective phenomena in individual detail. It's the same perspective you find in Bruegel's

busy squares, crowded with individuals, or in Hokusai's prints, with their scenes of fishermen at work, of travellers fording a river.

And if we remember the artist's Anarchist convictions, we can see that *Place du Théâtre Française* is in fact a political image. Under Pissarro's benign survey, the boulevards are made into an ideal human landscape: a harmonious, self-adjusting system of individuals and crowds, humans and animals and machines, negotiating each other without conflict. There are no collisions, no runnings-over, no jams. There are no policemen, and not much sense that there's even a side of the road you're meant to drive on. Everything is working collaboratively. The activity of street and square (maybe slightly idealised) provides a small working model of Anarchism's utopia, the cooperative society without controls. And the vision is all in the point of view.

Camille Pissarro (1830–1903) or 'the humble and colossal Pissarro' as Cézanne called him, was the father figure of the Impressionists. Influential as a painter and a teacher, he exhibited in all eight Impressionist shows. The Franco-Prussian war forced him to London where he painted the byways of Upper Norwood and Crystal Palace. The high viewpoints of his last years stem from a degenerative eye condition that made him give up *plein air* work and paint his townscapes from the windows of hotels.

On the Sailing Boat 1819
Oil on canvas, 71 x 56 cm
Hermitage Museum, St Petersburg

CASPAR DAVID FRIEDRICH

A picture is a view. A view implies a viewer. A viewer is a self in the world. So a picture, through its view, doesn't only show us a scene from the world. It can show us how a self experiences the world.

Caspar David Friedrich's *On the Sailing Boat* is a scene with two figures in it. A man and a woman, hand in hand, sit on the prow of a yacht. They face away from us, looking out across the water, across some river or sea, towards a farther shore where lies the edge of a city, their destination. It is a horizon of gothic spires, glowing, misty, barely visible. It's some non-specific over-there place – a dreamland, another world, sheer distance and beyond. They're on a soul's journey.

We see this couple in the middle of an active voyage. Their boat leans over on the water. The mast swings across. The sail bellies out and flaps, the rigging strains, the loops tug. The dramatic asymmetry of the composition stresses the irregular conditions of their course, caught as they are in the turbulence and contingencies of nature.

And the viewer is caught up with them. This isn't a scene that you can stand back from and survey. It's a view that involves you. The boat itself is the immediate foreground, seen close up. It goes out of the frame, cut off at the picture's edges. You're looking through its mast, boom, sail and tackle. This is a subjective shot – like a view through a bush or a keyhole. Visually, you're in the thick of it.

On the Sailing Boat shows you an experience of the world. You're given a particular viewpoint – and with that comes a particular standpoint, too. Somebody looking so close up through this boat's framework must be aboard it. You're not a stationary or grounded viewer. You're afloat on water yourself, rolling sideways and moving forwards.

In other words, you're urged to identify with the couple on the prow. They're your proxies or projections. They look the same way as you look. You're on board with them, on the same water and the same journey, travelling towards the same mysterious yonder. Looking at this picture, like them, you're cast as a self at sea in the world. But there is another dimension to your experience.

On the Sailing Boat has a calculated composition. At one level, the scene is thrown to the right, and cut off by the edges, and unstable. At another level, it has a firmly fixed structure. See how the shape of the yacht's prow is set within the frame. It stands symmetrical and centred. It makes itself the form of an upright gothic arch. The point of this arch touches exactly the line of the horizontal of the shore.

Through this underlying design, this geometrical subtext, the scene is righted, levelled, directed. The picture is held, pointed ahead. The view is filled with purpose. You may be on a swaying journey, but through it you're being taken onwards, on your way, aimed straight towards your goal.

It's a twofold experience that Friedrich offers to his viewer. You're striving in the midst of contingency – and also under the sure guidance of destiny. The couple may not know this, but you and the picture know.

Caspar David Friedrich (1774–1840) is the great painter of loss and longing. He painted Romantic landscapes – ruins, mountains, forests, oceans, nights. He said, 'Close your bodily eye, so that you may see your picture first with your spiritual eye; then bring to the light of day that which you have seen in darkness, so that it may react on others from the outside inwards.' He composes scenes in mystic symmetry. He obscures things in mist or distance. He puts a mute element bang in the middle – a back-turned figure, a tomb, a rugged cross. And the imagination rushes in.

Madonna with Saints 1505
Altarpiece, oil on panel transferred to canvas, 500 x 235 cm
San Zaccaria, Venice

GIOVANNI BELLINI

A vision. This happened about fifteen years ago. I was walking around in Venice, alone, and I found myself in front of the church of San Zaccaria. I hadn't been inside before, but I had a hunch it held something worth seeing, and I went in. There were other tourists there already. As I walked up the aisle I turned to look at what they were looking at – the altarpiece on the left wall. My first reaction was: 'Oh, so it's that one!' I recognised it from a reproduction. Then I began to have a hallucination.

Normally in these pieces I don't say 'I'. I assume that what I can see, anyone can see. On this occasion the first person is unavoidable. I hadn't taken any hallucinogens. I don't remember being in a fragile state. And when I say 'vision' or 'hallucination', I don't mean that what I saw was something that wasn't there - not entirely. The experience I had was firmly focused on this famous painting by Giovanni Bellini. Still, it's unlikely someone else would see it as I did then.

The image transfixed me. Specifically, it was the two male saints, St Peter and St Jerome, that transfixed me. The other figures – the female martyrs, the Madonna and Child, the musical angel – weren't really involved. Of the male saints it was the figure of St Jerome that especially gripped me: this stout and powerfully self-contained figure, with his beard and his red and white hooded robe, looking like Santa Claus, but very dignified.

What was so gripping? It wasn't like looking at a man-made painting, but at an unfolding scene. There was an appearance of real solidity in these figures, and of real space and air circulating them. And the stillness of the figures appeared, not as in a still image, but with the hovering stillness of figures that are holding themselves very still. There was no illusion of action, or any definite alteration in the image. Nor did the saints seem to be addressing me. They had their own business.

In a way, the hallucination was true to Bellini's art. It picked up on actual qualities in the picture. The male saints are made to command our attention – standing in their gathered robes, front-facing but inward and self-absorbed. And the way they're painted, rendering them very solidly but also in slightly

soft focus, is designed to create a sense of airiness and mobility. But you could appreciate these qualities, and not at all experience them as a perceptual illusion.

There was another dimension of fascination too, harder to evoke. The experience had been preceded by, or rather set off by, a realisation that I knew the image already (perfectly true, I knew it from a Bellini book). But in fact the whole experience was accompanied by a sense of recognition, a feeling that this was to be expected and had been waiting – of course, this is how it was going to be, when I saw this picture.

I suppose it went on for five or ten minutes. In that time I wasn't in a trance, or unconscious of my surroundings or of my fellow viewers. It was a vision that I could move in and out of, and I had to, because the church was dim, and the lighting was on a timer. I had to keep feeding 200 lire coins into the meter to keep the picture lit – no one else felt like contributing – and then go back to the position in the middle of church from which the hallucination seemed to work best. But eventually, as I expected, it started to fade.

In *The Varieties of Religious Experience*, William James gives four characteristics of a mystical state. It is transient. It is passive. It is ineffable, defying adequate expression. It is 'noetic' – it seems to bring a kind of knowledge, it's an illumination, a revelation, full of significance and importance, even if this can't be articulated. My own experience ticked the first three boxes. But for the last, which seems the crucial one, probably not. Though inexplicable and transfixing, it was clear to me that it came from my mind. It wasn't a message from beyond.

So I don't consider this vision as a mystical experience. I don't consider it an artistic experience either. Sure, art can excite states of heightened attention, sensation and emotion. This was something different. In its own way it was marvellous. But I don't think of it as an ideal or peak artistic response, a hit that you should seek from paintings generally. It was a hallucination – sudden, baffling, lucky, meaningless. It's not the function of art to induce hallucinations.

Of course I went back on later visits and tried to repeat the experience. Of course it didn't work. I've always kept a special fondness for that figure of St Jerome/Santa. To some people, this kind of thing may happen all the time, with pictures and other objects. To me, it's never happened since.

Giovanni Bellini (c.1430–1516) was the leading Venetian artist of his age, 'the best in painting' as Dürer reported back to a friend in Germany. His characteristic pictures are of saints, Madonnas and wounded Christs. Whether they're public altarpieces or made for private devotion, these are contemplative images, with a serene but resonant stillness, a marked mercy towards the bodies they depict. His figures glow and suffuse into the atmosphere around them. He is a great painter of hands that gently hold. He is the greatest ever painter of the maternal bond, in numerous variations on the Madonna and Child, the grieving Mater Dolorosa and her dead son.

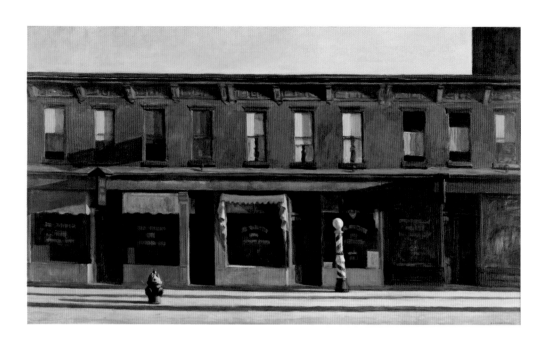

Early Sunday Morning 1930
Oil on canvas, 89.4 x 153 cm
Whitney Museum of American Art, New York

EDWARD HOPPER

'To see a landscape as it is when I am not there': the words are from the French religious thinker, Simone Weil, and the thought may sound impossible. For when I see a landscape, I am always there. I'm the person having the view, the person through whose eyes the scene is seen. I cannot see what a landscape would look like when I myself am not present and looking.

In fact, Weil meant her words to express a spiritual goal. I must empty and annihilate my self, and become a pure selfless viewpoint – and then I *can* see a landscape without *me* being there. Or better still, God can see it through me. The whole true purpose of human beings, Weil thought, was to stop blocking God's view. 'I cannot conceive the necessity for God to love me . . . But I can easily imagine that he loves that perspective of creation, which can only be seen from the point where I am. But I act as a screen. I must withdraw so that he may see it.'

And she developed this into a theory of art. 'All great painting gives the following impression: that God is in contact with its point of view regarding the world, with the perspective of it, without either the painter or the person admiring the picture being there to disturb the *tête-a-tête*. Whence comes the silence of all great painting.' When we look at such pictures we are in a sense not there. We are only eavesdropping (the visual equivalent of eavesdropping) on God's view of the world.

Weil gives no examples. Her favourite painter was Giotto. She would probably not have had any time for the art of Edward Hopper. But if you're after a view of the world that seems undisturbed by a human viewer, his work is certainly a candidate.

Hopper's *Early Sunday Morning* shows a stretch of street. It's a terrace of two-storey properties, with a line of shopfronts running beneath a line of red-plastered apartments. It may be a street in New York, where the artist lived. The row is viewed flat-on. From the kerb of the pavement to the guttering of the roof, it becomes a formation of straight parallel bars. With no dramas of near and far, or of up and down, the scene runs levelly across the picture.

The shape of the picture, low and long, emphasises the ongoing length of

165

the street. The doorways and windows make a regular and almost uniform series. It's not quite uniform – there are small variations among the blinds, curtains, awnings, hanging signs, the lettering on the shop windows and the pilasters between them. But there are no big surprises in this sequence, and no surprises are implied beyond the picture's edge. The scene says 'etc.' The sky continues clear from left to right. Only a perfect square of featureless brown in the top right corner, presumably some higher-rising building behind, punctuates this continuousness.

The lighting tells the time. A cool light casts long shadows across the pavement from the fire hydrant and the barber's pole. It is early morning. These shadows add extra horizontals. A third very long shadow falls down the middle of the pavement, going right across the picture, suggesting that a tall lamppost stands off-scene, somewhere to the right – or is it a step in the paving? Either way, the thin bar only ups the sense of continuousness.

Nothing happening. That's the visual message of the image, with its parallel horizontals, its repetitive sequence of units, its long stretch. It's also the narrative message. The light declares early morning, and the title specifies early Sunday morning. No one is around. No one is up and about. No one is awake. The street is empty. The people in the apartments sleep. The only visible event is the steady fall of the light. You're looking at a scene without consciousness.

And maybe you aren't there either. 'When we were at school,' Hopper remembered, 'we debated what a room looked like when there was no one to see it, nobody looking in even . . .' This is the strangest effect in his paintings. He can depict individuals sitting by themselves, or empty rooms, or deserted streets, and he can suggest that the individuals are absolutely alone, the rooms and the streets absolutely empty. There is no one else on the scene at all – no one there to see it, even. What the picture shows is something that isn't being looked at. Its viewpoint is unoccupied. It is a view without a viewer.

How's it done? How can this sight suggest that it's not being seen by anyone? Well, there is sheer probability. At this time of day and week there would likely

be nobody around. This particular moment of lightfall must often pass without any witnesses. (Part of the magic of a clear early morning is that the world is so intensely visible – never more so – but that very few people are there to see it.)

But it's more than that. *Early Sunday Morning* has the look of a scene that isn't being looked at. It's without any particular focus. The eye just scans along it; and nothing in it suggests a human eye observing, noticing, taking an interest. The pole and the hydrant, things that might stand out as creature-like – a man and a dog, almost – refuse to become protagonists. They are merely two inanimate interrupting fixtures that catch and break the light. The rendering of everything is even, solid, not too sharp. There is no point at which the picture gets excited. Nor is it assertively blank, in a surreal or alienated way. It is simply, calmly there. With you or without you, the silent street goes on.

Edward Hopper (1882–1967) was once a dubious figure. In the century of distortion and abstraction, he steadily pursued an atmospheric realism. He spent many years as a commercial illustrator. His work was popular. Was he just a poster artist? Now that his standing is established, the question can be safely answered: yes and no. Some of his pictures, including the most famous (*Night Hawks*, *Office at Night*), are indeed better in reproduction. While others, which you might flip past in a book, are miracles of subtlety on canvas. And some, like *Early Sunday Morning*, are wonderful both ways.

Silence 1799–1801
Oil on canvas, 63.5 x 51.1 cm
Kunsthaus, Zürich

HENRY FUSELI

The psychology of shapes is good business. Find out your shape-personality type and you'll know yourself, both well and profitably. The square? Your colleagues will come to you for help. The circle? People will bring you their personal problems. But the rectangle? It seems you are always the last to know. And the squiggle? Why do you embarrass your friends?

These ideas are not new. Shape and character have long gone together. There was Johann Kaspar Lavater who presided over the craze of head-reading. And there was his close friend, the artist Henry Fuseli. In one of his aphorisms, he pronounced: 'The forms of virtue are erect, the forms of pleasure undulate. Minerva's drapery descends in long uninterrupted lines; a thousand amorous curves embrace the limbs of Flora.'

Fuseli's equations are primarily tips for the artist. Upright, that's the way to convey virtue. No doubt they could be adapted into a personality test. (Undulations? You are the amorous type.) But Fuseli's priorities were creative. He wanted to embody feelings.

His painting called *Silence* seems to have been made according to a shape-character programme. Its shape is so explicit. This image is occupied by a single, strong, simple form. A sitting cross-legged figure is bent right over itself. It is composed into a self-enclosed shape. As far as a human body can be, it's rolled up into a ball.

The form could hardly be clearer. But what it means or expresses, is not so clear. Silence? Take away its title, and you could find many alternatives. Or try to complete the phrase: 'The forms of . . . are enclosed.' There's no obvious single answer.

Perhaps the link between shapes and meanings isn't so sure. This image can be a test case. It presents a very definite form, in a very pure state. It's powerful, all right, but with little to focus its power.

Where are we? Nowhere. There's darkness, and within it just enough light and cast shadows to indicate floor and wall, some kind of cavern or niche, in which the figure squats. Around it there's a void of non-specific gloom. The scene might be set, not in some real if vague location, but in a metaphysical space.

And who is this presence? A kind of nobody. There is no story or myth suggested, to give us emotional context. The figure is probably male, but not certainly. Its hands could be female. Its garment is ambivalent. Its cascade of hair is too. Its age is indeterminate. Its glowing monochrome hints at a ghost as much as a body. It might be sage or sibyl, spirit or symbol.

Its most extreme feature is its head. It's bent over, level with the shoulders, and is almost identical to the shoulders, three blobs in a row. Its long hair looks like a third limb hanging down between the arms. No facial expression, then: the head hides within the body. This being has sunk into itself.

Sunk is right. The pose and the shape might have a sense of strain, of imposition, as if the figure had been forced or forced itself into this ball. It might have looked agonised or imprisoned within its containing form: hunched shoulders, clamped arms, as in William Blake's versions of this pose. But the figure in *Silence* has no rigidity and no resistance. It relaxes into its closure. And if you look at it, blurred or from a distance, you can see that it's like a closed hand (thumb on the left): not a tight fist, a softly closed hand.

But expressing, meaning what? It's a deep state, no doubt, because the form involves the figure so fully. And obviously it's not a state of elation or extraversion: this is a turned in and drooping form. Yet nor is it a state of real pain, because this figure surrenders into its form.

You could find a range of feelings here. It is melancholic, dejected; it is pensive, meditative; it is withdrawn and secluded – there are all these possibilities, related but distinct. On the other hand, you don't find the hard feelings that might go with this form – like depression, or repression, or defensive egotism. The figure isn't in that kind of grip.

So *Silence* speaks in an abstract emotional language. Its feelings go inwards and downwards. Its feelings are soft and not hard. Beyond that, it doesn't say anything specific. It's too basic. It's an archetypal figure, personifying a very fundamental state of the human mind. True, if this figure belongs to one of the shape-personality types, mentioned above, it surely has to be 'circle'. But you probably wouldn't go to it with your personal problems.

Henry Fuseli (1741–1825) was a high-minded artist who seems not to have quite realised or admitted his highly original talent for sensation. He was Swiss-born and he trained as a priest. He moved to London. He looked back to the noble sublimity of Michelangelo and the Greeks. He was deeply inspired by Shakespeare and Milton. He took a pioneering interest in Norse mythology. And he invented a pictorial theatre of sexual bondage, bug-eyed madness, creeping horror, witches, fairies, spooks and grotesquely posing musclemen. His *Nightmare*, in several versions, is a classic of gothic. It's a world half-comic in its excess, which proved an inspiration both to contemporary cartoonists like James Gillray, and to the superhero comics of the twentieth century.

Girl in a Blue Dress c.1914
Oil on canvas, 43.9 x 34.9 cm
National Museum of Wales, Cardiff

GWEN JOHN

There are stories about people being turned into pictures. Whether it's Keats' *Ode on a Grecian Urn* or Poe's *The Oval Portrait*, the basic idea is that becoming a picture can give you immortality – at the cost of your life. In a picture you're eternally preserved from decay, but frozen in suspended animation. (Oscar Wilde's *The Picture of Dorian Gray* turns the idea on its head: while the living man doesn't change, his portrait ages horribly.)

These stories dwell on one aspect of being pictured: being immobilised. But they neglect another, equally important aspect: being flattened. That's understandable. We know what it feels like to be static, for short periods anyway. The experience of being flat, of withdrawing into a two-dimensional existence, is beyond us. It's very hard to evoke this side of pictorial life in language. Paintings can show it, though.

The women in Gwen John's paintings are often in a state of withdrawal. The *Girl in a Blue Dress* is one of them. She's sitting still and quiet. She looks out, but her gaze in unfocused, absorbed in reverie. Her hands are clutched tensely in her lap, arms to her sides. Her body retreats into a self-contained shape that doesn't send out any feelers into the surrounding picture.

It's a simple composition, just a figure and a background wall. She's seated on some kind of stool, with her back against the wall. She's turned to the right, but (contrary to normal portrait practice) most of the picture area is to the left of her, behind her, not in front of her. Her postition pushes her to the side, restricting her personal space.

Now things start to flatten. It happens in various ways. The uniform pale russet background, which is notionally a flat wall behind the woman, can easily be read as simply the flat painted surface of the picture. And the narrow band of dark shadow she casts onto it suggests that she's right upon this surface.

The figure itself is far from being fully rounded. The darker blue strokes of shading that edge her lighter blue dress are abrupt and shallow, as if she wasn't a solid body, more a piece of board or card. She is composed of simple areas of colour, like bits of marquetry. The soft, all-over, evenly unassertive

dabs of paint, with which the whole image is composed, equate the figure and the background.

Every hue is blended with white, and the blanching of the colours makes the whole picture seem to be fading out, towards some neutral tone, some total loss of contrast, in which no feature is distinct. The expression of the woman's mouth is already barely visible. She is paleing away.

You don't think of the *Girl in a Blue Dress* as apart from the picture in which she appears. You don't think of the model (whom John never identified) as someone who temporarily sat to be painted, and went on her way. The woman *is* the painting. She withdraws from life, fading into its surface, pressed like a flower.

One or two elements resist the retreat into two dimensions. The clasped hands in particular stand out with a sharp solidity. But that only emphasises how far the rest of the woman has receded into flatness. She is absorbed into the picture just she is absorbed into herself. She is becoming nobody.

Gwen John (1879–1939) used to be the sister of the more famous Augustus, but their fame has changed places. The flamboyant Gus now looks shallow and hearty. The recessive Gwen is a reclusive, introspective, obsessional talent in true modernist mould, doing the same subject over and over, pursuing small differences, a Morandi of the solitary female figure. She lived in France. For a time she was Rodin's model and lover. She joined the Catholic Church and painted a series of portraits of a long-dead nun.

Interior, Mother and Sister of the Artist 1893
Oil on canvas, 46.3 x 56.5 cm
Museum of Modern Art, New York

ÉDOUARD VUILLARD

A picture has a frame. I don't mean the piece of plain or decorative woodwork that's put around it, sometimes upstaging it with dazzling gilding, often casting an inch-thick band of dark shadow right across its top. I mean simply the picture's edge or edges, where it comes to a stop, cuts off. These outer limits are usually straight, usually four in number and usually in a rectangle.

And usually, with a representational picture (occasionally with an abstraction) they are understood as visual limits. The picture's edges are the edges of a view. They make an aperture through which we look at a scene. The frame shows a section of the visible world – a world that is presumed to continue, off-picture, unseen, outside the frame. A figure in the picture can be imagined going out of view, simply by passing behind this limit. Or a figure may be shown half-cropped by the frame, partly in view, partly out. There's no question of a figure bumping into the frame.

But sometimes the edges take on a more palpable existence. Figure and frame can come into contact. For example, the sides of the picture may be equated with the sides of an open window, at which somebody appears, perhaps leaning upon the sill, or resting a hand upon the window's frame. Or maybe the picture's edges are identified with a more extensive barrier – imagine a scene where the bottom edge coincided with a floor that was seen exactly at floor level. Mantegna does this sometimes. All the figures, near or far, are standing on or walking along the bottom of the image.

That's one way: the edges are made to align with some solid barrier in the depicted scene. But there are also pictures with no such realistic pretext, where (all the same) somebody relates to the frame as if to a physical boundary. Nothing in the scene accounts for this confinement, yet the figure seems to be bodily cramped by the sides of the image, as if inside a box. That sounds like a puzzle. How can the mere edges enter into the three-dimensional world that's pictured?

Well, you could give a more realistic explanation. You could say: the figure is not being somehow physically confined by the picture's edge, it is squeezing itself into a view. It's like in a wedding photo, when the photographer makes

the people at the edge of the group come in a bit, so they'll all be in shot, and in the photo they appear to be squashed by the sides of the image itself. But either way, box or view, the cramping effect can occur quite naturally, without any sense of tricksiness.

Édouard Vuillard's paintings from the 1890s are dedicated to confinement, physical and psychological. They're set in rooms, in the home (where his mother ran a sewing business), among the family, among women mainly. For some artists of that time, like Munch, the room is a sheer nightmare scenario. Being stuck in a room, by yourself or with others, is an image of hell. With Vuillard it's different. He's both claustrophobic and claustrophiliac. His gorgeous images may be suffocating, but suffocation is the only air they can breathe. Sometimes it's bliss, sometimes not.

In *Interior, Mother and Sister of the Artist*, the confinement becomes menacing. It's an anti-mother picture, I'm afraid. The figure of the mother is in command here: central, seated, in widow's black, in a confident masculine pose, legs apart, hands on knees, elbow and foot thrust out towards the left. And to her left stands, shrinks, her daughter.

In the 1890s Vuillard strongly emphasises the surface arrangement of colours. Flat decoration overrides all. A camouflage effect often occurs, in which patterned dress, patterned furniture fabric, and patterned wallpaper merge into one another. It is a blotting paper world, and it can create an idyllic fusion of people and environment, a feeling of total at-one-ness and at-home-ness.

But here the camouflage effect is used strategically, dramatically. It is only the young woman who is spectacularly overridden by pattern. In contrast to her darkly shaped, sharply distinct mother, she in her checked frock half-disappears, absorbed into the spotted wallpaper behind her. She is an almost invisible presence, a nobody.

A nobody – but still confined. The young woman, backing away from the forceful maternal presence, is stopped, backed up against the wall. She looks not just camouflaged but flattened, as in a centrifuge. There's no escaping the powerful figure, no way out of the room, but no room within it either. The colour

harmonies are warm and cosseting, but this is a grim image of retreat and entrapment, submission and dependency.

The frame only aggravates her situation. It hems the young woman in. Backed against the wall, she's also pressed against the left-hand side of the painting. And most strikingly, for no apparent motive, this tall, thin girl bends down so that her head lies beneath and within the top edge, as if stooping under a very low ceiling or a yoke.

She is subjugated, humbly and meekly fitting herself into this picture-space – this view or box – that her mother's figure dominates. She is stuck between mother and frame. She is elbowed out of the way (her bending body echoes the sharp bend in her mother's arm). She is literally pushed into the corner.

Édouard Vuillard (1868–1940) was the great homebody of early modern painting. With Pierre Bonnard he is classed in a two-man movement, *Intimisme*. But unlike Bonnard, who had about the same lifespan, Vuillard's genius is confined to a single decade, the first ten years of his career, when he worked at home. The scenes are small, saturated, with tight spaces, close atmospheres. Their blurry forms and dense, matt hues, make a moody synthesis of room and furniture and human presence. And after 1900, the space is opened up, the air is let in, and everything goes. For forty years he carries on as a nice middle-of-the-road figurative artist. It's a self-transformation as dramatic as any in modern art.

Madame Paul-Sigisbert Moitessier, Standing 1851
Oil on canvas, 147 x 100 cm
National Gallery of Art, Washington

JEAN-AUGUSTE-DOMINIQUE INGRES

In the long dream-sequence that makes up chapter fifteen of James Joyce's *Ulysses*, the feelings and fantasies of the book's main characters are given free rein. At one point Leopold Bloom finds himself in court, on trial for sending obscene letters to 'several highly respectable Dublin ladies'. Three of the ladies appear to denounce him. In language that parodies court reporting, and society pages, and light pornography, each of these severe and magnificent women is portrayed as a high bourgeois divinity, a giantess dominatrix, lapped in kinky luxury.

First is 'MRS YELVERTON BARRY *(in lowcorsaged opal balldress and elbowlength ivory gloves, wearing a sabletrimmed brickquilted dolman, a comb of brilliants and panache of osprey in her hair)* Arrest him constable. He wrote me an anonymous letter in prentice backhand when my husband was in the North Riding of Tipperary on the Munster circuit, signed James Lovebirch. He said that he had seen from the gods my peerless globes as I sat in a box of the *Theatre Royal* at a command performance of *La Cigale*. I deeply inflamed him, he said ...'

Next 'MRS BELLINGHAM *(in cap and seal coneymantle, wrapped up to the nose, steps out of her brougham and scans through tortoiseshell quizzing-glasses which she takes from inside her huge opossum muff)* Also to me. Yes, I believe it is the same objectionable person ... He addressed me in several handwritings ... He lauded almost extravagantly my nether extremities, my swelling calves in silk hose drawn up to the limit, and eulogised glowingly my other hidden treasures in priceless lace which, he said, he could conjure up.'

And third, 'THE HONOURABLE MRS MERVYN TALBOYS *(in amazon costume, hard hat, jackboots cockspurred, vermilion waistcoat, fawn musketeer gauntlets with braided drums, long train held up and hunting crop with which she strikes her welt constantly)* Also me ...'

Grandeur and innuendo. The fashion notes, with their pedantic and opulent detailing of costumes and accessories, are positively intrusive. They direct attention to the body – the naked flesh – that these fine accoutrements enclose and adorn. In fact, the dress descriptions are entirely in tune with the salacious euphemisms of the indecent letters: the peerless globes, the nether extremities, the hidden

treasures. And the 'huge opossum muff' could appear in either context.

These women are portrayed as both goddesses and dolls – massively powerful, and passive objects to be dressed up. They are like statues, simultaneously mighty and incapable, untouchable and all too touchable. They are like portraits by Ingres.

The formal, female, upper-middle-class portraiture of Jean-Auguste-Dominique Ingres is an extraordinary spectacle. It's inspired by a mixture of classical ideals and high fashion. The sitters are gift-wrapped trophy wives. Their poses come from antique statues and from Raphael. They are objects of worship and items of property, incarnations of money and beauty, expensive fabric and expensive skin. Ingres' rendering of texture, pampered flesh, coiffured hair, silks and velvets and furs, is perfect. Its realism almost disguises the fact that these women are not quite human.

Like the haute couture dresses they inhabit, their bodies are creations, put together. The anatomies don't properly articulate. The limbs go soft and limp. They seem to be filleted, or like empty skins filled with water, lolling. They're not really attached to the rest of the frame. Their flesh becomes tender morsels of swelling chubbiness, swathed in gorgeous stuffs.

There's a general air of molestation and handling – of voyeurism, or the tactile equivalent of voyeurism. The dresses and pillows are prinked and patted and flounced, tweaked and stroked and plumped. There's a consciousness that a clothed body is a naked body that's pressed all over. And this feeling is picked up by the exquisite brushwork. The meticulous finish of each depicted surface becomes, so to speak, the painter's finishing touch. These are portraits in which at every point (to use the old divorce court phrase) intimacy occurs. The statue serenely holds its pose, while everything is fingered.

The portrait of *Madame Paul-Sigisbert Moitessier, née Marie-Clotilde-Inès de Foucauld, Standing* is the supreme example. Fascinated with this lady, and taking endless pains, Ingres painted her twice. He tried out various poses and costumes. The other picture, *Madame Moitessier, Seated*, head in hand, in oceans of floral dress, in the National Gallery in London, is probably better

known. But this upright version in a dark frock is Ingres' masterpiece of the ambiguous statuesque.

She stands before us, a theatre of the body. Her shoulders are moulded into an hourglass curve of beauty. Her left arm hangs half-limp and dislocated, decorated with jewels. She has an anatomy whose visible parts are only joined by the dress from which they emerge. The head and neck are jawlessly fused. There is nothing to suggest that this body could occupy a different position from the one it's pictured in.

Her face is fixed, symmetrical. It lies firmly on the picture's centre-line, and it faces directly out, and it's framed by a perfect centre parting (the dark curtains of hair echo the opening décolletage of the dark dress). It has the features of a stern Roman matron, but set between chubby cheeks and ending in a sulky pout. The blank, lazy eyes do not make contact. They drift off in divergent directions towards the sides of the face. Sedate and sedated, she is a kind of zombie.

In this portrait, Ingres demonstrates how power and passivity meet in impassivity; how inertia can be both helplessness and strength. The goddess is a dolt, a body, a posh clothes horse, but her monumental dumbness makes her superb. The image is a triumph of 'objectification'. It suggests that for a human being to be turned into a commodity – a parcel of sex and money – is actually a kind of apotheosis. And to all the obvious lines of moral and political criticism that a picture like this invites, Ingres simply replies: 'Yes, and how marvellous, how divine!'

Jean-Auguste-Dominique Ingres (1780–1867) used to be thought a terrible old square, the last word in reactionary academic art. Now he's often seen as an exciting weirdo. His art is an unstable mixture of lots of different things – classicism, pornography, photographic realism, exotic fantasy, historical revival, modern fashion. Bizarre and artificial myth and religious scenes were produced alongside luscious fields of nudity and brilliantly vivid portraits. He was one of the greatest draughtsmen in the European tradition. His true heirs were Degas and Picasso.

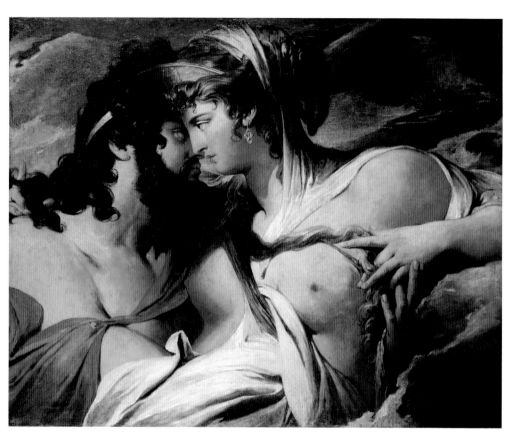

Jupiter and Juno on Mount Ida c.1800
Oil on canvas, 101.6 x 127 cm
Sheffield City Art Galleries

JAMES BARRY

Paintings seldom show much interest in human relationships. Interpersonal psychology is not their field. They can give you the expression of high and low passions, but rarely passions passing between two people, with all the knots of interaction and reciprocation. Monologues they're good at, sometimes they do a whole lot of monologues at once. Dialogue they generally leave to the theatre and the novel.

Or perhaps it truer to say that, when it comes to the interpersonal, paintings tend to cast the viewer as the other party. Portraits present you with a single human face, rich in soul, for you the viewer to get into an interesting face-off with. Nudes present you with a solitary naked body for you the viewer to desire. But how about a painting that depicted *two* people, in a complicated psycho-sexual relationship – that does sound unlikely, no? Maybe it sounds more than a painting by itself could even manage. Certainly not before the twentieth century, anyway.

Think again. James Barry's *Jupiter and Juno on Mount Ida* is just that. It's a portrait of a marriage, and the marriage has clearly gone terribly wrong. The story comes from Homer's *Iliad*, and no doubt the full authority of the classics was required to make this picture's nasty subject matter seem at all palatable.

Homer tells how Juno seduced her normally errant husband, in order to put him to sleep, so that she would have a free hand helping the Greeks attack Troy. You see that the setting is among heavenly clouds, and that Jupiter's eagle is present top right. But not much background information is required by this highly explicit image of sexual hatred and marital bondage.

In the original, the two figures are over life size. But the picture itself is not so big that you need to stand well back from it. It just means that, at a normal viewing distance, the presence of these scaled-up figures becomes a bit oppressive. Their framing is even more so. It brings us right up close to them. The couple are tightly confined, at shoulder and head, by the picture's rectangle. And everything within the scene conspires to make their intimacy as uncomfortable as possible.

It's an embrace between two soft, heavy bodies. And as their clothes fall off

them, they disclose isolated pockets of flesh, strangely divided up by trailing strands of robe and hair. This map is difficult to read. The separate areas are hard to identify as this body part or that – or as his or hers. Juno's right breast can easily look for a moment like a bit of Jupiter. His forearm could be her raised thigh. Their bodies sink into one another.

The rolling pink expanses of skin are played off against the fiddly-twiddly details round the edge – fingers entangled in spiralling locks, fingers entwined in fingers. The hands here have a way of appearing suddenly round the corner out of nowhere, as if with a life of their own. And when you've counted to three, you may notice that the unaccounted fourth, one of Jupiter's, is already up and under Juno's shift, the little finger pushing eagerly ahead beneath the cloth.

Desire has taken them over. But a loving kiss is emphatically avoided. Their mouths don't meet. Their overlapping profiles pass firmly one behind the other. Yet in this very act of holding apart, they become visually locked together. The tip of Jupiter's nose seems to lodge in Juno's upper lip. Their respective curving headgears join in a single arc. The hairlines are continuous. Most striking are the glazed and glaring eyes, which you can't but see as directly eyeballing each other, even though their gazes must be rigidly bypassing.

Mr and Mrs Gods. They are united. They are separate. They hold back, and despite themselves they drift together, they jam and they fuse. With no need of speech or writing, with purely pictorial resources, Barry contrived this image of ugly amorous malevolence, a subject that has no precedent in painting and no successor.

James Barry (1741–1806) was an Irish painter who came to London and aimed high. He aspired to epic scenes in the grand manner. He did stirring subjects from Milton and Shakespeare, and heroic self-portraits, and peculiar mixtures of myth and contemporary politics. He was a strange talent in an unstable age, pointing ahead to the stranger talents of Fuseli and Blake and Gillray.

Inconstancy, Anger, Despair from *Vices* 1303-6
Fresco, approximately 120 x 55 cm
Scrovegni Chapel, Padua

GIOTTO DI BONDONE

There is a short poem by Bertolt Brecht, *The Mask of Evil*.

On my wall hangs a Japanese carving,
The mask of an evil demon, decorated with gold lacquer.
Sympathetically I observe
The swollen veins of the forehead, indicating
What a strain it is to be evil.

It comes to a surprising conclusion. The usual roles are reversed. The observer looks on, not with fear or excitement, but with calm compassion. The monster is in pain. If only evil could escape from its strenuous mission.

This is not the normal lesson. No, the devil has all the best tunes, or so they say, and his followers have all the fun. We'd all do it, if we dared. Don Juan: exploitation. Faust: power. Cain: murder. But we don't dare, so we make myths and heroes out these diabolical figures, and ourselves knuckle down to caution and morality. Satan himself, the great rebel, is the archetype of romance. He and his demonic gang are models of strength, energy, freedom, resourcefulness, charisma. The rest of us are weak, insipid, enviously dull. And in stories it's the same. The good are lifeless. The bad are inevitably adventurous. Etc. Etc.

So Brecht is wise, helping us to see through the appearance of masterful strength to an imprisoning strain. And Simone Weil is clear too, illuminating the difference between fact and fiction. 'Nothing is so beautiful and wonderful, nothing is so continually fresh and surprising, so full of sweet and perpetual ecstasy, as the good. No desert is so dreary, monotonous, and boring as evil. This is the truth about authentic good and evil. With fictional good and evil it is the other way round. Fictional good is boring and flat, while evil is varied and intriguing, attracting, profound, and full of charm.'

But if that is true, it's not exclusively true. There are some images that portray evil with an utter lack of charm or variety. Milton's Satan may have a touch of daring superhero, but look back to Dante's *Inferno*. At the centre of this hell you find a very different Satan: vast, immobile, frozen in ice, unceasingly

weeping, and chewing on sinners like a mill. As a devil, he's suffering from something worse than strain. As a character, he's frankly a disappointment. Pure evil is pure monotony.

Giotto was Dante's near contemporary. His frescoes in the Scrovegni Chapel were painted shortly before Dante's *Inferno* was begun. They have a big Last Judgement at the end, with three tiers of scenes on the walls, illustrating the lives of Jesus and his forebears. But there is another row, almost at floor level, with fourteen individual figures spaced out: seven Virtues and seven Vices.

The Virtues are standard. There are three theological Virtues; Hope, Faith and Charity, and four classical Virtues; Justice, Wisdom, Fortitude and Temperance. But the Vices are not the now familiar Seven Deadly Sins. Giotto's cast is more closely paired with the seven Virtues. He pictures Despair, Infidelity, Envy, Injustice, Folly, Inconstancy and Anger. Three are shown here: Inconstancy, Anger, Despair.

When you compare them, Virtues against Vices, the comparison is clear and as expected. The Vices *do* have better tunes. They are obviously more interesting figures. The Virtues are serene, upstanding, solid. The Vices are passionate, animated, dramatic. Giotto's pictorial devices actually work for them. The fourteen figures are all painted like statues, carved in stone, standing in niches. Each of them, Virtue or Vice, has a physical fortitude, imbued by its stone nature.

But the Virtues are like statues anyway. Their static medium is only confirmed by their static characters. They are already stone-still, fixed in their niches. The Vices have a dramatic tension between their medium and their action. Their niches become little theatres, in which they appear before us, throwing themselves into convulsions. Each figure, though solid as sculpture, has – paradoxically – the articulation of a living body, in the most expressive gestures.

Look at Inconstancy, a wildly careering acrobat. She rides a wheeling disc, and tries to keeps herself rolling and upright, with wavering arms holding her swinging balance, while she teeters on a sloping floor, a jacked-up triangular

surface, made of inlaid marble. Her circular fling of garment echoes the whirl of her wheel and creates a cartoon motion effect.

Despair has hanged herself with a scarf from a bending crossbar on her niche, caught at the moment of suicide, dropping like a dead weight. She has despaired of salvation. She is going straight to hell. A little devil swoops down to carry away her soul. This figure has literally provoked an audience response. Iconoclasm! Her head and her devil have been vandalised, scratched out, defaced – a recognition that this evil is intolerable, and must be obliterated.

But Anger is the most powerful invention. See how this woman stretches herself out, wrenches open her dress, forcing it – at first you don't see the shape – into an outlined rectangular void over her heart. Her face smarts from the harm her feelings are doing. There is no sense of her fury being directed outwards, as malevolence or cruelty. It is all internalised. She's tearing herself apart.

Giotto's *Vices* are studies in self-destruction. They are not boring, no, but nor are they heroes or rebels or charmers. They have nothing of power or attraction. They are helpless, driven, raging creatures. Their isolated poses show their doom. Their deep damage is only being done to themselves. Evil always gets its perpetrators. Psychology – medieval or modern – teaches that. But a waiting hell probably helps too.

Giotto di Bondone (c.1267–1337) is the founder of European painting. The Florentine introduced emotional power and three-dimensional realism. An early commentator said he 'translated the art of painting from Greek into Latin', that is from flat Greek-Byzantine icons to solid Roman statues. Stanley Spencer still felt his influence: 'What ho! Giotto!'

The Presentation c.1740
Oil on canvas, 64 x 53 cm
Louvre, Paris

PIETRO LONGHI

The raked stage was once a favourite feature of Shakespearian and Wagnerian productions. It rose up, away from the audience, a ramp. Sometimes the gradient seemed immensely steep, like an impossible hill in a dream. The slanting set was a metaphor for instability, struggle, crisis. Lear and the Fool, Wotan and Brünnhilde, somehow kept their footing. A feeling of literal precariousness and physical danger was often part of the drama.

With a picture that's done in perspective, the floor or street that recedes away from the viewer also 'rises up' towards the middle of the picture. The inverted commas are there because of course it isn't meant to look as if it's rising. It only means that the view is seen from a point above ground level, and the ground is therefore visible. But since the view is projected onto a flat surface, there's the risk that the ground stretching away will look more like a sheer slope.

There are pictures that give this impression. They make receding ground resemble a raked stage. This happens because they overlook a key rule of perspective, which says that things that are nearer should be bigger than things that are further. If you neglect that, and make all your figures, near and far, the same size, and then position them at various distances along on the receding ground, they will not look like figures who are themselves receding. They will look like figures positioned on a steep slope, some higher up than others. They will make a supposedly level floor look like a rising ramp.

It is a classic perspective mistake. But when it happens, it may not be obvious whether it's a error or an effect – whether the artist hasn't mastered the rules, or is deliberately bending them, so as to generate (as with those theatre sets) a sense of difficulty and crisis. For example, in a highly charged social situation.

Enter Pietro Longhi. This Venetian painter is a singular figure. His work fills a gap. There are several well-known omissions in European painting – hardly any paintings of sex, for instance, none of childbirth. Longhi's work makes you realise that there are also very few pictures about the perils, pretences and anxieties of social interaction.

Novels and plays and operas are full of sticky social situations. Paintings are not. They have plenty of heroic moments, very few awkward moments. But the theme is perfectly visual. That is shown by one of the few visual artists to fully engage with it: H.M. Bateman, in his 'The Man Who . . .' cartoons.

These scenes typically show an appalling social gaffe and a scandalised reaction. They demonstrate how strict social proprieties – with their punctilious codes of behaviour, the strong emotions invested in them, the crises that are always lurking – are rich in pictorial drama. In a Bateman picture, the viewer must notice the terrible *faux pas*, which is often a quite inconspicuous action, and the horrified response of the witnesses, which is often rigidly suppressed. In the best of them there's a marvellous play of clues and signals, and the sense of a world in which everything is acutely sensitive.

Now imagine a Bateman cartoon prior to the crisis, a social scene where the code is yet unbreached, where behaviour proceeds according to the rules, but everything is precariously on the edge. You're in a scene by Longhi. His milieu is far less innocent than Bateman's. It is filled with flirtation and deception, hints and secrets, masks, fans, glances, gestures, nudges and whispers and winks – all happening in a public realm where such surreptitious carryings-on are acknowledged by everyone, but where appearances and standards must be kept up. The scene is sometimes the street, sometimes the salon, sometimes the drawing room.

In *The Presentation* it is the drawing room. Two figures, a gentleman and a lady, approach two other ladies. There is hierarchy here. Those two ladies are at home (the children peep out behind them). One of them, putting her fan to her chin, is superior to the other. They're mother and daughter, perhaps. In fact, this lady is the senior figure in the room. It is she to whom the gentleman is introducing the lady in the dark blue dress. The pair have their backs to us. Their faces can only be imagined. But the situation is clearly delicate.

Longhi's doll-like figures emphasise the highly artificial and game playing nature of his world. Yet in this scene there's a sense of something very serious and possibly dangerous in process. The hostess ladies stand in blazing light. The

approaching pair is in darkness. The man's coat swirls as he turns, but stiffly. It looks like slow motion, or the kind of impeded motion, as if through a heavy medium, that happens in dreams. You're made to feel that the approaching pair are paralysed by the anxiety of the encounter; or that at this critical moment, as they begin to bow and curtsey, they experience every millisecond as it passes.

Crisis. Suppressed hysteria. And it is the floor that's crucial. It rises steeply upward. It looks like the floor in one of those crooked houses that used to be found at funfairs, buildings where everything was at an angle. Longhi has perpetrated the classic perspective 'mistake', making all his figures, nearer and further, on the same scale, so they seem to stand higher and lower. The pair are several heads lower. They must make their approach up a gradient that at some points looks unclimbable. They might slip and fall at any moment.

It must be an intended effect. The slope stands for hierarchy, for uncrossable social distance, for precarious status, for the danger of the moment, for sheer insecurity and disorientation. The area of empty floor in the bottom left is without any clear sense of plane. It's just a void space, into which the little Maltese dog in the corner (borrowed from an earlier Venetian painting, Carpaccio's *Vision of St Augustine*) gazes up in amazement.

Pietro Longhi (1702–83) is one of the disparate talents of eighteenth-century Venetian art. In style he's a delicate but almost naïve painter; in social consciousness he's a sophisticate, depicting the highly self-conscious and playful little world of Venetian society. Ladies and gents in their masks and tricorn hats intrigue in the living theatre of carnival. Street life is full of rip-off merchants, fortune tellers, quack doctors, mountebanks. It's a place where everyone is on the game and in the racket and part of the show. In the midst of it, wild animals from Africa appear: the artist is also known for *An Exhibition of a Rhinoceros* in the National Gallery in London.

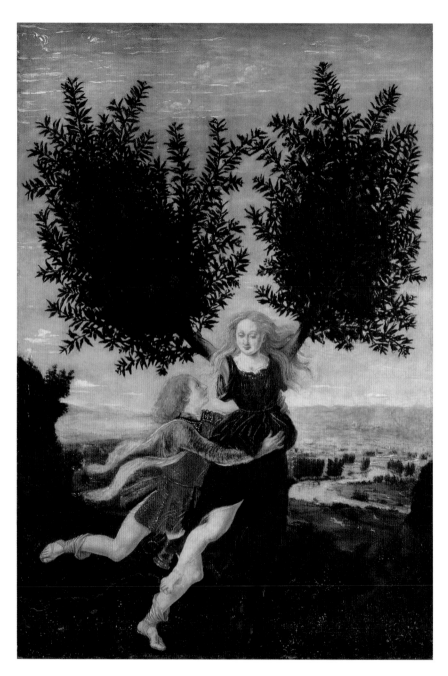

Apollo and Daphne 1470–80
Oil on panel, 29.5 x 20 cm
National Gallery, London

ANTONIO POLLAIUOLO

Seen any good jokes lately? Do paintings ever make you laugh? It sounds an odd kind of question. Humour in European art is not much appreciated, or much noticed. Very few of our famous pictures are famous for being funny.

When it comes to literature, the division into tragedy and comedy is ancient and fundamental. We recognise comic genres and comic effects. There are comic plays, comic poems, comic novels. There's a body of critical and theoretical writing about literary comedy. From time to time the old comedies even make us laugh.

With paintings the matter is more obscure. Traditional art writing borrowed many ideas from literature, but it never made much of comedy. Comic painting gets the occasional mention, and seems to be treated as a very minor sideline. Even today, when there are academic studies of everything, there is no art-historical study of comedy in Western painting.

Of course you can guess what it might contain. There'd be some well-known and semi-well-known names, like Bruegel, Teniers, Steen, Longhi, Hogarth, Wilkie, Daumier. There'd be much broad comic business, scenes of pranks and roguery, sauce and randiness, voyeurism, gross-out, scoffing, stupidity, slobbishness, social vanity. And there'd be stuff that our ancestors found funnier than we do: old age, ugliness, deformity, poverty, physical infirmity and cruelty.

If the study was honest, there'd be many borderline cases too – pictures where a modern viewer can't tell whether laughs were meant or not. Maybe that's the trouble with the whole topic. There's nothing more elusive, nothing more specific to cultural texture, than a sense of humour. The comedy of the past is one of time's great casualties. Scholars can strive to recover the lost meanings of pictures. The lost laughs they leave alone. The cause feels too hopeless.

But more positively, there's the question of whether painting has its own kind of comedy. Beyond cartoons, with their funny captions and situations, and beyond caricature, with its funny faces, is there such a thing as pictorial humour? Well, there seem to be paintings that make pictorial jokes. It's not

that their subject matter is inherently ludicrous. The comedy is in the way they put it. They are staged and shaped and arranged for comic effect. And even after centuries they can still raise a kind of laugh.

For example, there's a picture by Antonio Pollaiuolo of *Apollo and Daphne*. The story comes from Ovid's long poem *Metamorphoses*. The god Apollo is maddened with love for the virginal nymph Daphne, and runs after her. As he's about to seize her, she calls out to her father, a river god, to save her. At once she takes root, and is transformed into a laurel tree. In Ovid the incident isn't particularly funny (though some of his stories about people being turned into things do have a humorous slant). But in this little early Renaissance picture, it is.

The joke is in the extreme abruptness and incongruousness of the change. Unlike other images of the subject, and unlike the poem, the picture gives no impression of gradual, graceful, organic transformation. The fleeing nymph raises her arms in alarm and appeal, and they just go *Whoomp! Tree!* with a flourish like a conjurer's bouquet. True, just telling the story, you can see how Daphne's fate might have comic potential. A woman waving her arms in a gesture of 'help!' is turned into a monstrous vegetable. But it takes Pollaiuolo's picturing to bring this potential out.

He makes the transition from woman to bush so awkward and disproportionate. The lifted limbs become growing branches, but the shapes of the vegetation don't suggest a natural flowering and ramification of the human frame. You just have these two enormous blocks of foliage, a pair of separate full-grown hedges, roughly symmetrical, each one as large as the rest of Daphne's body, sprouting straight out of her shoulders. It's a very undignified, top-heavy transformation. It's calculated to emphasise, not the strange likeness of human and plant anatomy, but the great difference between them. It's more of a splice than a metamorphosis, and it comes with a jolt. In mid-action the running, waving woman is massively encumbered and immobilised.

What's more, the shapes of these burgeoning bushes almost fill the whole top half of the image. This means that the tree/woman is further immobilised, held cramped within the picture's frame. In fact, stuck motion is the dominant

trick here. The image evokes various kinds of movement – figures running and gesturing, branches rapidly growing – and then jams them. At one point it does this explicitly. See how the body of Daphne is literally divided between motion and stasis: one of her legs is on the wing, but the other is firmly planted in the ground. And Apollo, pursuing at speed, his cloak streaming in the air behind him, hits her like a lamp-post.

Was Pollaiuolo trying to be funny? Five hundred years on, you may feel unsure. Perhaps he was just trying to be startling. After all, old pictures are full of marvels, miracles, martyrdoms, which to us can look absurd, although they weren't meant to, they were simply meant to look extraordinary. On the other hand, it's not only viewers who make mistakes. Artists make them too. They can misjudge their flights of fancy, and tumble inadvertently into farce. Viewers may then mistake these mistakes for deliberate comedy.

The incongruity and the jammed motion in Pollaiuolo's painting must be deliberate devices. He's out to spring some kind of surprise on us. The story is about a bizarre transformation, and about a moving body getting stuck. He's trying to get that over. And if (hard to believe) his intentions are not specifically humorous, our impulse to laugh is only a slightly wrong turning. His picture has inherently comic structures. It certainly deserves a place in that great collection-in-waiting – the joke book of Western art.

Antonio Pollaiuolo (1432–98) is a name with a tricky string of vowels. It means hen-coop-man, from his father, a goldsmith, who had also sold poultry. Working in Florence, often in collaboration with his brother Piero, Antonio was a painter, sculptor and engraver. He pioneered the Renaissance fascination with the human figure. He may have been the first artist to study anatomy through dissecting corpses. His best known images are small paintings on wooden panels showing the body going through its paces – fighting, wrestling, running, shooting. His great print, *Battle of the Nudes*, is a parade of action poses. He taught Botticelli.

Stenographic Figure 1942
Oil on linen, 101.6 x 142.2 cm
Museum of Modern Art, New York

JACKSON POLLOCK

Modern art kept comedy at bay. It had good reason to. People were always poking fun at it, and calling it a joke, and accusing the artists of playing a prank on the public. Modern artists had to be careful not to give too many hostages to this line of attack.

There was also the clear likeness between Modernist distortions and traditional comic art. A lot of twentieth-century art adapted the vocabulary of cartoon and caricature. But it shouldn't be equated with such low cultural activities.

That's certainly what we're taught. Modern art's comic aspect is repressed. What look like funny figures aren't really funny. They are pure formal experiments, or acts of violence, or deeply disturbing. Anything to keep them on the right side of straight.

And surely nobody would turn to the New York Abstract Expressionists for a laugh. They're the apostles of heroic agony, serene spirituality, apocalyptic fire. Yet one of those artists has one big funny moment: Jackson Pollock. It's a moment of comedy of madness.

In the early 1940s Pollock aspired to be an artist of high seriousness. He was drawn to 'automatic writing', used by the Surrealists to access their deep unconscious. He was using Jungian symbols and runes, archetypal, mythic and ritual elements.

But then there is *Stenographic Figure*. It was a breakthrough work. Piet Mondrian, the great Dutch abstract painter, was in war-exile in the USA and scouting for the patroness Peggy Guggenheim. He noticed and commended it. 'I have the feeling that this may be the most exciting painting I have seen in a long, long time, here or in Europe.'

Mondrian had rightly spotted something unusual. There was 'the impression of tremendous energy', that looked forward to the famous drip paintings. But there was something else, something not followed up. It's the only comic picture from Pollock's hand. And it has the energy of total breakdown.

Stenographic Figure? This is presumably not an office scene. The artist implies that he's taking dictation from his unconscious. Yet it is a figurative

picture. It seems to have two figures in it, even though the title says only one. They are, in effect, stick figures, made up of undulating lines. They're very loosely constructed, but with heads and arms and bodies.

The one at right is seen in profile, with its hand put down. The one at left appears face on, with its hand flipped up. They meet across a table, or across a bed, and are engaged in some passionate confrontation. All is energy, speed, spontaneity. Anatomy is action. The looping limbs and gesticulations of the pair arise directly from the painter's own looping gestures.

The space around them, meanwhile, swarms with graphic mayhem. It's as if their speech balloons or thought bubbles had burst, and spilt out all their contents. Bits of writing take flight, flicker in the air, judder and collide. In the process they lose their regular shapes. Free-form glyphs, sudden squiggles and shudder lines – plus some letters, numbers and signs too – crowd about the loopy figures.

And *loopy* is the word. It's a term that connects shape and psychology. (Whether this half-jokey phrase refers to the flailing bodily motions of the loopy, or the irrational circles of their minds, is another matter). Loopiness characterises this pair. It's not the only such expression at work. They're *twisted* too. Perhaps they've been on a *bender*. The language of mental derangement uses many visual metaphors, and this picture is alive with them.

Scatter-brained is another obvious term, or *scatty*, applying well to the ciphers scattered around the figures. *Haywire* is a good one too, since those jumpy marks look like strands of hay and wire. Or again, from their resemblance to crackling electrical activity, or to lightning strokes, these squiggles can point towards *brainstorm*.

There's also the possibly significant fact that, in English, several common words for the wild mind are drawn to the letter 'z': crazy, zany, dizzy, buzzing. The zigzag letter is a designed for this role, with its switchback action. Zigzags turn up all over *Stenographic Figure*. It is another, if subliminal, indication of derangement.

Is this reading too much in? You may wonder how many of these effects

the artist himself could have been conscious or indeed 'unconscious' of. And you may find especially dubious the idea that lurking verbal metaphors, and the secret power of the letter 'z', are making the going in this semi-abstract picture.

But these associations arise easily from the imagery. Loops, twists, bends, scatters, squiggles, zigzags, storms etc. – you may or may not choose to translate these visual forms into verbal terms, but the translation is natural enough. Visual or verbal, this is the language that *Stenographic Figure* uses, and what gives it its sense of craziness.

It's a comic craziness. The comedy isn't strange. It comes from the bouncy, doodly lines of the critters and glyphs. It comes from the clear presence of funny faces – the profile head with its anxious bug-eye and its fishlike nose, and the face on head with its gleeful vacant smile. This figure delivers a casual gesture of insult, or maybe a cuff, and its body zooms straight up like an exclamation mark.

Doolally, skewiff, *Stenographic Figure* performs in an undeniably cartoony register, though with a liberty few cartoons dare. It takes pains, and gives them slapstick painlessness. It turns breakdown into something light and weightless, the self thrown up in pieces.

Jackson Pollock (1912-56) was the hero of post-war American art. His myth emphasises the violent boho outsider – and then the celebrity casualty. But his inspiration took work. Emerging from numerous influences, his unprecedented works arrived in the late 1940s – the canvases flat on the studio floor, paint dripped and poured on them, 'all-over', in dense and layered webs, done in a dance of activity. 'I am nature,' he said. His achievement was to make human artefacts that have the fascination of natural phenomena. It lasted a few years. He got too drunk to paint at all, and fatally crashed his car. Briefly he had been visited.

Hoop-La 1965
Acrylic on canvas, 203.7 x 203.5 cm
Tate Gallery, London

JEREMY MOON

Comic abstract painting? There's tragic and sublime abstraction. There's lyrical and mystical abstraction. There's rational and mechanical abstraction. But comic? How would that go? Could an entirely imageless picture be funny? What would a joke about shapes and arrangements and colours be?

It would be a painting by Jeremy Moon. He does it, and he shows how it's done. His paintings are made of pure forms, but you're never allowed to contemplate a resolved composition. They have something else: a twist, a teeter, a fault-line, a false note. There are patterns hidden in seeming randomness. There are apparent schemes that collapse. Look at *Hoop-La*, and learn.

Granted, a detailed description of an abstract painting is often intolerable. And a description designed to demonstrate that it's a funny one: that sounds suicidal. But Moon's paintings are often explicable. Their tricks may be subtle. Their elements are clear. His visual wit is worth an analysis.

First point: his edges are sharp. Abstraction has come in soft and hard edges. It did so from the beginning. Kandinsky's forms bleed and blur. Malevich deals in geometrical shapes. Hard edges aren't automatically comic. (They aren't in Malevich or Mondrian.) But hard edges are hospitable to comedy. They introduce abruptness. They establish definite relationships between things – which are then susceptible to definite wrong notes.

The basic relationship in *Hoop-La* is explicit enough. The painting has two components, in two colours. There are five identical blue discs. They lie on a red background. This background, the whole picture, is a perfect square. The discs lie in an arcing formation flying across its top.

But already it's presumptuous to say discs. After all, three of them are sliced off by the picture's edges. Their roundness is only implied – implied by the other two, which are visibly circular. Delete those two, and we wouldn't see the three as circles. We'd see them as semi-circles, little bites or tabs or cheese holes, taken out of the picture's sides.

The composition strains our eyes – between what we actually see, and what we might deduce. Is this a group of two circles and three semi-circles, laid out

within the frame of the picture? Or is it an arc of five full circles, which has partly strayed off-picture, out of view?

There are tendencies each way. Those three sliced-off discs are perfectly cut in half. That gives them a stable identity as semi-circles. We don't need to see them as circles *manqués*, but as what they actually are. And we don't need to imagine a wider arcing formation of which they might be part.

Other things weaken the arc. The discs are spaced unevenly around its curve. And they relate neatly to the picture's edges in further ways. See how the second disc precisely touches the top edge, and the third one lies exactly halfway across. The picture's frame, not the implicit arc, rules their positions.

Yet the arc formation can't be ignored. It has its own identity too. It curves firmly across the top of the picture. It recalls the dial of an old telephone. And not all the discs relate so neatly to the picture's edges. Look at the fourth one, the most visible circle: you might think it was perfectly cornered, equidistant to top and right side. It isn't. It's nearer the top. Its position lies in the arc's orbit, not the frame's framework.

There's the fundamental oscillation in *Hoop-La*. What motivates the placing of the five blue discs – the arc or the frame? They might be set evenly at intervals around their arc, and randomly related to the frame. Or they might all be neatly related to the frame, with no arc formation at all. As it is, they're a bit of both. Each way they raise expectations of more regularity, each way fail.

And do the discs themselves lie on a perfect round? Is their arc the section of a circle? That's the question lurking in this composition, and the answer is: almost certainly, yes. That conclusively strengthens the identity of the arc. And it sets up the terms of the picture's final mismatch: the arc's circle against the picture's square.

It's the decisive wrong note. Circle, square: regular shapes, but they don't meet properly. It's as if one had mislanded on the other, aimed but missed. The design is frustrating. Expectations again are raised and failed. You shake your head. You never feel those five discs are all where they ought to be.

Meanwhile, the colours are at work too. This violety-blue and the orangey-

red are opposite colours, complementaries. They intensify each other. And as your eyes play over these spots, you get spots before your eyes. Your staring engenders after-images, optical discs bouncing around the real discs, keeping things moving.

But in a paradoxical way. After-images take on the complementary colour of the images that engender them. So the after-images engendered by these blue discs are red like their background. These secondary discs flicker, red on red, in a most fleeting, vanishing way, as the faintest brightening. It's a touch of lightness. It's a literal winking.

Jeremy Moon (1934–73) was a British sixties painter, a contemporary of Bridget Riley and Patrick Caulfield. He read Law, and took to painting as a hobby. His originality emerged immediately. He devised a unique form of abstraction. The flat fields of paint, hard edges and geometrical shapes were a little bit Pop Art (in their sweetshop hues) and a little bit Op Art (in their eye-jumping surfaces). But their ideas were extremely various. They had subliminal real-world echoes and off-kilter arrangements. They played a twist on the purity and solemnity of the Modernist abstract. They're exuberant and witty. The effect is more than fun, though. His works are light, but firmly heartening. They're pictures about living well in an unpredictable world. Moon was killed in a motorbike accident in his late thirties. After a posthumous retrospective, his name faded away. In the past few years he's been reviving.

The Bed 1893
Oil on cardboard, 54 x 70.5 cm
Musée d'Orsay, Paris

HENRI DE TOULOUSE-LAUTREC

Complaining about the 'high incidence of love-making in television drama', the poet and critic D.J. Enright once wondered if it was something inherent in the medium itself. Television tends to concentrate on intimate human relationships. Television also demands action, '. . . and the small screen, it seems, is exactly the size of a double bed.'

Not literally, of course. But what makes this phrase click is not a matter of size. It's the fact that the small screen is almost exactly the shape of a double bed that makes the connection. Not that the camera very often adopts the kind of overhead view in which a bed's shape perfectly fills the screen's rectangle, and proves the point. And not that this theory does much to explain the equally high incidence of sex on the big (and much wider) screen. Still, the idea of a TV set as a box-bed retains its charm.

And painting? Has anyone ever bemoaned, or welcomed, the high incidence of love-making in the art of painting, ancient or modern? Would it occur to a critic that the canvas was sometimes the same shape and size as a double bed? Does that most frequent of life situations, four bare legs in a bed, appear with a comparable frequency in art?

Anyone who expects that representational art will necessarily be representative of the world in which it's made is in for a disappointment. Cars were roaring past outside, and there are very few images of the motorcar in twentieth-century painting. Babies are continually being born, and there is hardly a scene of childbirth in the whole of Western art (it's what all those Nativities never show). Sport, stomach ache, class conflict – about quite a few basic human things they were largely uninterested, the old masters.

When it comes to couples in double beds, what does painting know? There are nudes, who may be sexually available but are never sexually engaged. There are solitary figures in bed, dreaming or dying or dead. And there are various sex dramas in which a bed is present, but only as the setting for a catastrophe – the wife of Potiphar trying to ensnare a reluctant Joseph, Vulcan surprising Venus and Mars in flagrante, Psyche shining forbidden lamplight onto her mystery lover Cupid, Tarquin assaulting Lucretia.

It is hard to explain an absence. True, the respectable art of painting avoids showing overt genital activity: this gets sidelined to more private and informal media, prints and drawings. But that ban would still leave room for a range of more or less decent bed scenes, of couples amorously or sleepily together. They don't get painted. Toulouse-Lautrec's *The Bed*, made at the end of the nineteenth century, is one of the first pictures to show the normal case.

In a sense, obviously, it isn't 'normal'. The couple lying snug in bed are both women. But to see it as a transgressive image isn't quite right either. There wasn't a tradition of painting heterosexual couples in bed to be transgressed. It might actually have been more shocking if Lautrec had made one of his figures male. And you could say that he uses one minority (lesbianism) to usher in another (a double bed scene).

Still, *The Bed* keeps things slightly unclear. There are related images by Lautrec that show two women in bed, embracing, kissing, lolling half-naked. So it is likely that his subjects here are female lovers too – likely, but not definite. The two short-haired heads could be a boy and a girl. And their passivity and apartness make it possible, just, that they're sharing a bed for some non-sexual reason.

There might be something going on beneath the blankets, but indicating human action through thick bedclothes is one of the most difficult problems of drapery. You could equally see a pre- or post-coital scene, two heads lost in one another's gaze, or (if the left-hand head has its eyes closed) one waker gazing at one sleeper.

Body-wise, the emphasis is all on being buried snug and deep under masses of heavy bedding, lost in a bed like children. The two bare heads just peep out, islands of consciousness in a great mass of stuff. You feel the fusion of body and bed, and the fusion of the two bodies via their shared bed. The way the tufts of their pillows make a single horned shape stresses their twosomeness.

Does the fact that this picture (like many pictures) is itself roughly bed-shaped make a difference? Very subliminally, perhaps. But what the image dwells on is not the length of the bed, or the length of the bodies in it. Rather, it wants to make you feel the bed's breadth, as something unlimited and oceanic.

The band of white sheets and pillows flows across the picture from one side to the other, disappearing off either edge. The two heads float, just surfacing, in its billowing, cascading current. This sense of indefinite watery flux, of bed as sea, is an old metaphor for sleep and dreams, though another old metaphor, of bed as ship, may also be present: the 'horned' pillows hint at a blowing sail.

It's only a hint. A more designy artist like Klimt might have given these metaphors their head, reshaping the bed's forms into something unmistakably and implausibly marine. Lautrec's draughtsmanship holds onto the real particulars of bedding, and so incites your empathy. You can just imagine it, this tucked-up closeness, this sense of safety, this loss of consciousness, this bliss that is a bridge between childhood and adulthood. Though it has so seldom tried, perhaps only painting can really understand the double bed.

Henri de Toulouse-Lautrec (1864–1901) was not all that small. After teenage sporting accidents, the legs of the young aristocrat stopped growing. But he reached about five foot. A precocious draughtsman, he learnt from Goya, Degas and the Japanese printmakers, and became one of the great crossover artists, working between painting, caricature and poster illustration. He dwelt in and on the bohemian leisure world of late-nineteenth-century Paris, the bars, music halls, theatres, circuses, brothels, where high life and low life mixed. His genius was essentially graphic. He was a shape-maker, a master of the fluid and the spiky outline, of stance and gesture, with a superb sense of where to place a form within the picture's rectangle. His art is a performance in tune with the theatrical and social performances it portrays. He died young, from alcoholism and syphilis.

INDEX

Bold marks main entries

PICTURE CREDITS

The publishers would like to thank those listed below for permission to reproduce the artworks on the following pages and for supplying photographs. Every care has been taken to trace copyright holders. Any copyright holders we have been unable to reach are invited to contact the publishers so that a full acknowledgement may be given in subsequent editions.